PORTRAIT OF
A COUNTRY ARTIST

"I take a fresh look at Tunnicliffe's three works and I am glad that he is an associate and that the Academy has purchased these paintings, for they hang there as proof of English genius."

Sir Alfred J. Munnings, President of the Royal Academy, writing in *Studio*, September 1944.

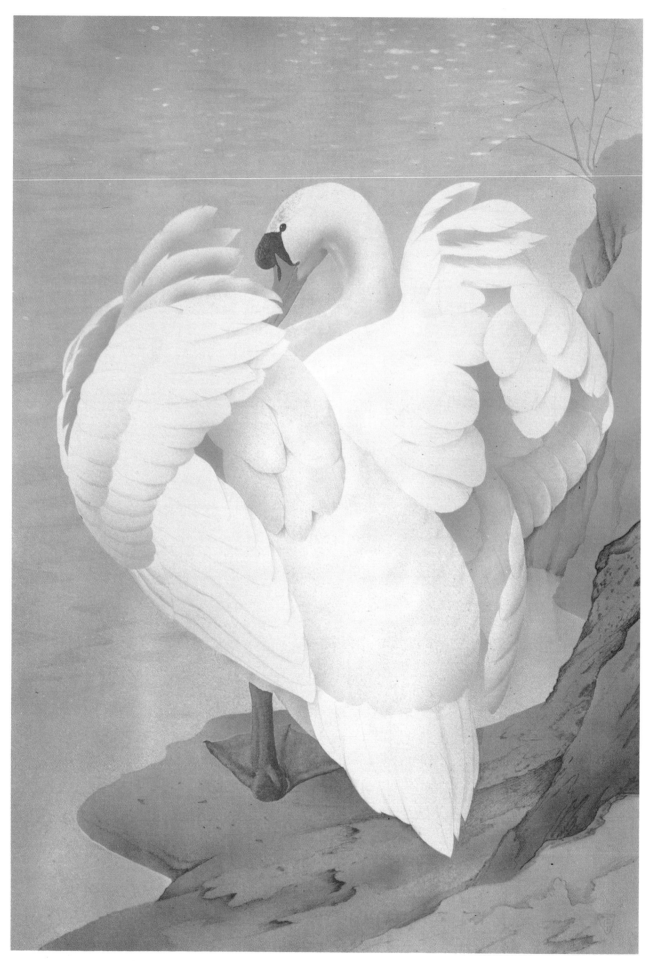

Cob. Oil on unprimed cloth (1937/8).

PORTRAIT OF

A COUNTRY ARTIST

C. F. Tunnicliffe R.A.
1901–1979

by

IAN NIALL

LONDON
VICTOR GOLLANCZ LTD
1985

Titles by C. F. Tunnicliffe available from Gollancz

A SKETCHBOOK OF BIRDS (paperback)
SKETCHES OF BIRDLIFE
TUNNICLIFFE'S BIRDS

First published in Great Britain 1980
by Victor Gollancz Ltd,
14 Henrietta St, London WC2E 8QJ

First published in Gollancz Paperbacks 1985

British Library Cataloguing in Publication Data
Niall, Ian
Portrait of a country artist: C. F. Tunnicliffe
R.A. 1901-79.
1. Tunnicliffe, C. F. 2. Artists—England
—Biography
Rn: John McNeillie I. Title II. Tunnicliffe, C. F.
760'.092'4 N6797.T85

ISBN 0-575-03694-X

Designed by Cornelia Playle
Printed and bound in the Netherlands
by Drukkerij de Lange/van Leer bv, Deventer

This book is dedicated to the memory of Margaret Tunnicliffe, the artist's mother, to the memory of Winifred, his wife, and to Mrs Dorothy Downes, his sister. These three sustained Charles Tunnicliffe in critical phases of his life.

⤚ ACKNOWLEDGMENTS ⤙

The author and the publisher acknowledge with gratitude the assistance and co-operation of the many private collectors, museums, galleries and other bodies who have loaned pictures for reproduction in this book. Particular thanks are due to Charles Tunnicliffe's sister, Mrs Dorothy Downes, for her continued hospitality and practical help, and to Dr Noel Cusa and Mr Robert Gillmor. Others whose help in various ways has been invaluable include: Mr Keith Cheyney, Mrs Barbara Hargreaves, Mr Reg Wagstaffe, Mr T. G. Walker, Mr Seán Hagerty, Mr Antony Witherby, Mr Paul Stride, Mr Kyffin Williams, Mr John Busby, Mr Nicholas Hammond and the R.S.P.B.; Sir Gordon Hobday, Mr Aubrey Ridley-Thompson, Mr D. N. Edmundson and the Boots Company; Mr Matthew Evans and Faber & Faber Ltd; Mr Peter Shellard and J. M. Dent Ltd; Messrs William Collins Ltd.

CONTENTS

ILLUSTRATIONS

DUOTONE AND MONOCHROME

I

A Private Viewing

THE FIRST EDITION of Henry Williamson's *Tarka the Otter*, published in 1928, was without illustration. The illustrated edition came out in 1932 and the illustrator was Charles Tunnicliffe. I remember the book and the Tunnicliffe engravings for they seemed as much of an inspiration as Williamson's own work. A lot of people of my generation discovered the work of Charles Tunnicliffe in the next decade. Although I came to know and admire his work, and he had by then illustrated two of my books, it wasn't until the middle of the 1960s that I met him. Our first meeting was in connection with a television programme I was doing at that time. He proved to be exactly the kind of man our correspondence had led me to expect, a man who knew farm animals and husbandry as intimately as I knew them myself. Our backgrounds were similar. He was the son of a shoemaker turned farmer. My grandfather had been a blacksmith before he turned farmer. We had actually shared the same publisher, for Putnam who published *Tarka the Otter* had given Charles his first commission as an illustrator and had taken my first novel. In a way we had walked the same path. What I have come to know of Tunnicliffe prompts me to write this memoir of his life and art. Setting out to produce such a portrait the author often finds himself posed with the question of approach. Should a life story be a warts and all study or something hazed in romance? If the subject happens to be a famous political figure or a general who has helped shape the course of history the truth may have to be glazed. A great many artists are as notable for the scandalous lives they have led as they are for their masterpieces. In such cases the writer has a choice of siding with history as it may already have been written, or presenting something in contradiction. In my case there was no dilemma. I had chosen to write of a man who properly belonged in a pastoral background. His roughs, his finished drawings, his watercolours and his engravings confirm that he was this kind of man. Their excellence and the enormous output Tunnicliffe managed to achieve testify both to his genius and the fact that he devoted his entire life to work. Few artists can ever have worked harder. He was a down-to-earth man in every way; completely unpretentious, a craftsman as well as an artist.

This book is by way of being a testament to Tunnicliffe's devotion to his subject. There is

no drama of struggles with the component parts of dead horses, or starvation in the garret, because Tunnicliffe was never a soul in torment. His struggles were to cultivate his talent. It may be that he couldn't afford to indulge outward signs of that boiling frustration all artists are supposed to suffer from, but Tunnicliffe's was a basically phlegmatic nature. Like most of us, he remembered his frustrations and the way he was exploited once or twice but few artists would survive, or their works see the light of day, without exploitation of their talent somewhere along the line. What concerned Tunnicliffe was the production of work of the highest standard, and work that was authentic in detail. If he drew a collection of shore birds at roost, the dwarf gorse, the sea pinks, the rock plants in their background had to satisfy the eye of the botanist just as the plumage of the birds had to satisfy the ornithologist. He was a perfectionist. He did everything with meticulous attention to detail as a matter of personal pride. No one would find his group of birds, or preening swan, imperfect as the result of casual or careless observation. Charles Tunnicliffe was fortunate in that his steady cultivation of his art and the excellence of his output brought him recognition. Recognition as a bird artist certainly brought him a degree of happiness far beyond any kind of financial benefit. "I feel I know my birds," he told me once. The impression was that master bird artist though he was he was also master of the understatement, but there wasn't a suggestion of boastfulness in what he said.

Tunnicliffe had an instinct for the portrayal of natural behaviour in animals. It was a large part of his gift. His public recognised his artistry when they looked at his birds or his horses in a field, cropping necks under a rowan tree or looking over a fence. The viewer immediately sees something that was elusive but is now fixed, arrested as though a ciné projector had stopped abruptly on a single frame. There was, however, a great range of Tunnicliffe's bird artistry which the public did not see – his sketchbooks and field notes. In addition to these were the 'bird maps', as Charles Tunnicliffe himself called them. The bird maps or post mortem drawings were the subject of a special exhibition at the Royal Academy in 1974. Anyone who saw them could not fail to remark how they testified to Tunnicliffe's personal discipline and his devotion to a very special branch of art. Such measured drawings of birds were a life's work. They could never be completed.

When I first went to see him about our series of 'sittings' required for this portrait Tunnicliffe was handling a tiny female ringed plover which had been brought to him a few days before. This, one appreciated, was something he had to do. He had already made a 'map' of the female ringed plover but here was an opportunity to check what had already been done. The bird in this case was advertising its presence for it had been picked up dead on the shore more than a week before it reached his desk, but what matter? Stubbs had had his 'high' horses. I remember enquiring about the male of the species. Charles hadn't had one. I understood the enormity of the self-appointed task in the shake of his head. The record might call for everything in pairs, duck and drake, cock and hen, two by two into the ark, or onto the drawing board, but birds don't conveniently die in pairs, and the cock or the hen might never arrive. All specimens that did arrive were carefully checked out. The magnitude of this undertaking is understood by appreciating that beginning with male and female, adult and juvenile, we might go on to summer and winter plumage, northern and

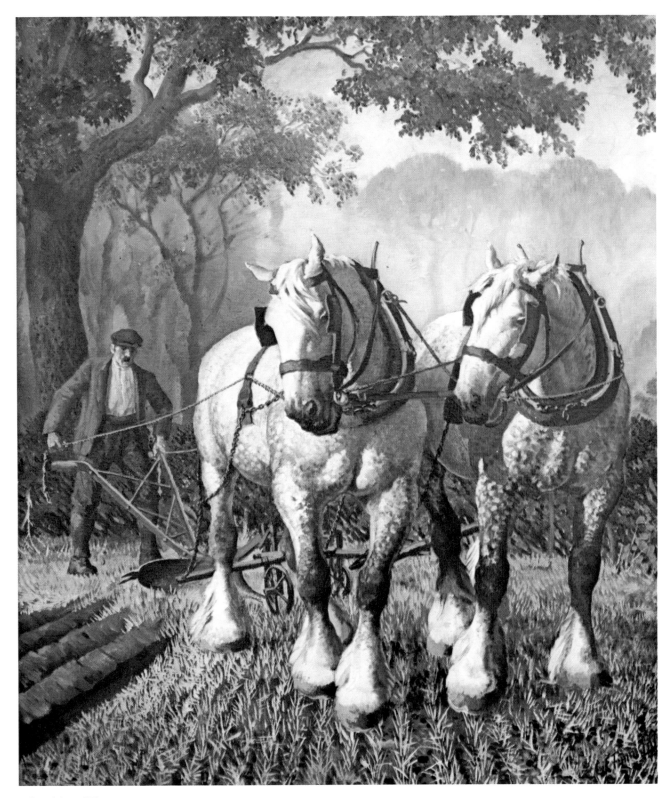

Ploughing. Oil on canvas.

southern varieties, winter migrants, transitional plumage, local variations, mutations ... Tunnicliffe was a bird artist undaunted by knowledge of what confronted him. He worked at it like a mason cutting the foundation stones for a towering spire, a cathedral that would take a hundred years to build. He accepted that he would never live to see it finished.

Until the present century, most bird and animal artists were either disinclined to do the necessary fieldwork, or to be fair to them, face the almost unsurmountable obstacles involved in studying wild creatures. It was, after all, a long way to the Highlands of Scotland to see the golden eagle feeding its young, or the sea eagle sailing along some Hebridean cliff. It was almost as hard to get to the Fens and stalk the bittern, or find the elusive bustard on the plain before someone like Colonel Hawker got there and shot it. The man with the gun was in fact a kind of benefactor for he often had the birds he wantonly killed set up by the taxidermist. The eighteenth- and nineteenth-century artist often had to turn to a craftsman's reference. Even Audubon suffered from this shortcoming. It was really a matter of communications and accessibility of material. The great wood engraver Thomas Bewick recorded in his memoirs the problems facing nature artists of his time:

> At the beginning of this undertaking [his book, the *History of British Birds* 1797], I made up my mind to copy nothing from the Works of others but to stick to nature as closely as I could – And for this purpose ... I set off from Newcastle on the 16 of July 1791 ... & remained there [at the museum at Wycliffe] drawing from the stuffed Specimens, nearly two months ... As soon as I arrived in Newcastle, I immediately began to engrave from the drawings of Birds I had made at Wycliffe, but I had not been long thus engaged 'till I found the very great difference between preserved Specimens & those from nature, no regard having been paid at that time to place the former in their proper attitudes, nor to place the different series of the feathers, so as to fall properly upon each other. This has always given me a great deal of trouble to get at the markings of the dishevelled plumage & when done with every pains, I never felt satisfied with them. I was on this account driven to wait for Birds newly shot, or brought to me alive, and in the intervals employed my time in designing & engraving tail pieces or Vignettes. My sporting friends however supplied me with Birds as fast as they could ...*

In spite of Bewick's pains, there is often a stiffness, a taxidermist's rigidity, about his birds and animals. T. A. Coward's *The Birds of the British Isles & their Eggs* suffered in its turn, for although its colour work was faultless the lifelike quality of the birds was questionable and Thorburn might have been painting decoys when it came to ducks! An artist needs to know the living subject and its anatomy. Charles Tunnicliffe tirelessly studied anatomy along with the other subjects laid down in a comprehensive art course. His own views on the importance of fieldwork are summarised in his book *Bird Portraiture:*

> It would be wisdom to familiarise yourself with the skeleton of a bird first and with the arrangement of the feathers afterwards. For the latter, the study of stuffed birds is helpful,

*Thomas Bewick, *A Memoir*, edited by Iain Bain, Oxford University Press

but only for the feather details. Do not use the stuffed bird as a substitute for the living creature. Rarely does one find a mounted specimen that in any way reproduces the form of the wild bird; for in the former, all muscular tension is lost, and no amount of craftsmanship on the part of the taxidermist can breathe life into its poor, dried skin.

There is a certain parallel in the lives of Tunnicliffe and of Thomas Bewick. They were both Northerners and countrymen dedicated to the art of engraving on wood. Bewick was a much greater technician than Tunnicliffe, as Tunnicliffe himself acknowledged without hesitation, but not such a good bird artist. Bewick was limited, as anyone who graduates through an apprenticeship to a craft is limited, by the world in which he has had to work. He came hopefully to London, a solid Newcastle man who disdained ornament for ornament's sake as then found in so much of the pious work of wood-engravers largely dependent upon the patronage of the Church. Bewick's refined techniques and exquisite craftsmanship brought a new dimension to the art of wood engraving. His vignettes have never been equalled. He was master of a clean, clear style of engraving. Poets and artists praised his sporting gentlemen as they stood hung about with powderhorns and shot pouches, clutching long-barrelled, muzzle-loading guns while they waited for their bewigged water spaniels to flush fowl. Bewick could conquer London, or so his patron suggested, but he hated it and departed north to his farmland background as soon as he could.

Charles Tunnicliffe found himself in London with visions of the Cheshire hill country still fresh in his mind. He too, was much appreciated as an etcher, yet Tunnicliffe's homesickness was as acute as Bewick's had been. He spent seven years in London but it didn't enter his head to remain longer to captivate that rich public either with his etchings, which were being collected at that time, or with his wood-engravings.

Tunnicliffe spent no time looking back, nor did he, having once left London, go back to conquer it. He went home to draw chickens, pigs and dogs for animal food manufacturers. His commercial engraving brought him much greater rewards than *Tarka the Otter*. Living on the green verge of his home town of Macclesfield he built a reputation as a nature artist. It was Tunnicliffe who brought the Shorthorn, the Shire and the Percheron to life in the pages of farming journals. His Black Minorcas clucked as they fed on Bibby's food and his sheep could be heard bleating piteously as they emerged from I.C.I.'s sheep dip. There were almost as many animals among his subjects as birds, and there were hundreds upon hundreds of these. His sketchbooks bulge with drawings – wonderful studies of horses, bulls, dogs and sheep. These references were crucial to his production of commercial work and book illustration. After *Tarka* he illustrated many books, among them the works of famous authors – H. E. Bates, Alison Uttley, Richard Church, Negley Farson, Ernest Hemingway, R. M. Lockley, Dr Fraser Darling. Talking to him about these it dulled my ego a little to hear him remark, "Well, I did do a book for him, but do you know, I had forgotten I had. I didn't like Williamson a bit but I remember him. I never met Hemingway or Negley Farson, but I managed to get the background they wanted and pleased them or their publishers." He could catch the atmosphere of Farson's lonely fishing haunts in British Columbia, just as he had done with drawings of Tarka confronted by hounds peering at him through the tree roots.

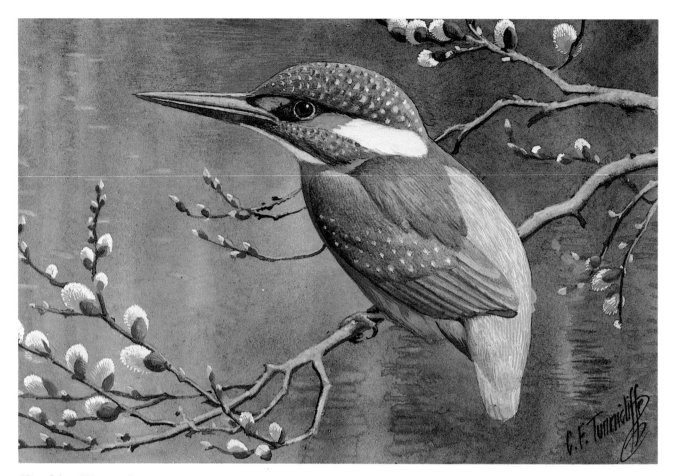

Kingfisher. Watercolour.

I was more than grateful to Charles Tunnicliffe for allowing me to look at some of the best work he had done, and allowing a small part of that work to be used in this book. I know how his drawings and paintings evoke the very sounds and scents of the subject he chose. He could achieve in a few lines or brush-strokes more than a thousand words could convey. I am proud of the fact that he illustrated *The Way of a Countryman* for me which he did before we met. He also illustrated a book of mine called *A Fowler's World*. This was something made for an artist of Tunnicliffe's ability. After this he took on *A Galloway Childhood*, another of my books, and one I like best of all the things I have written. Charles Tunnicliffe had penetrating insight. Whatever anyone else might say about bird portraiture and art, I know he portrayed the world of my childhood as no one else could ever have done. Every writer, I am sure, has a faint hope that his fantasy will get across and that the person who reads him will share it. The only way to be sure of this is to see the images produced, the work interpreted by an artist. Such a thing has only happened to me once in my life. Since we all gyrate, encapsulated, and can only gesture feebly in passing, as we try to communicate, I might say I communicated with Charles Tunnicliffe.

<p style="text-align:center">— 2 —</p>

The Drawing on the Wall

THE LITTLE VILLAGE of Langley in East Cheshire lies not far out of Macclesfield, a town as well known for its connection with the silk industry and silk-printing as Manchester is known for commerce and cotton. Langley, where Charles Tunnicliffe was born in 1901, was as quiet a little place as any to be found either in the Cheshire hill country or anywhere on the Cheshire plain to the west, but it was a quiet world at the turn of the century. The pace of life was less urgent than it later became after two world wars. If in cities mills hummed and presses clanged, the noise nuisance diminished until it was somehow lost under the weight of silence beyond the outer fringes of urban development. There was no need for a knocker-up like those who awakened people of mill towns on the far side of Manchester. In a little two-up and two-down house such as the Tunnicliffes lived in people might hear the clock chime next door. They went to bed, if not Wee Willie Winkie fashion by candlelight, by the light of the oil lamp. They slept soundly, undisturbed except by the calling of an owl or a cock crowing at the moon. There was as yet no threat of invasion by people with money to renovate and rebuild old country cottages and change their way of life. There were no commuters eager to find a dormitory in a quiet place close to the hills. People rose early because this was their habit and looked at the new day coming up behind the Derbyshire borderland. If there was a sound much louder than the churring of nesting starlings, or a bee busy on a flowerbed, it was remarked upon, for even on the road from Macclesfield to Buxton or Leek, in a triangle of which the little village stood, there was as yet no traffic of any consequence. That distant traffic rumble had yet to become a background to life and there were certainly no planes to lay vapour trails across the canopy of heaven. People who travelled long distances travelled by train. The steam engine held sway. In general, country people didn't go far in the day of the carrier's cart and the horse bus. The bicycle was most popular. A lady's cycle had a dress protector and was ridden in the sit-up-and-beg posture. The bicycle built-for-two had a great attraction, and the gentleman riding in front dressed in proper cycling gear, a knickerbocker suit, stockings and brogues, while his lady might wear fashionable cycling bloomers although more often a skirt that covered rather more of her limbs. People walked a lot and thought

<p style="text-align:center">[15]</p>

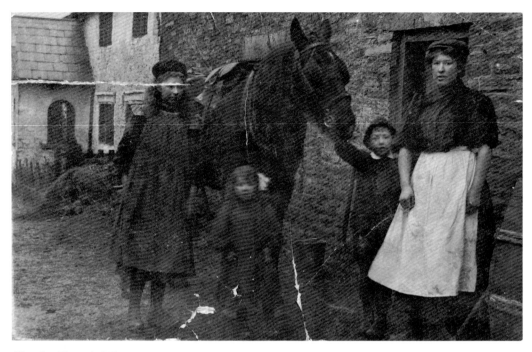

Charles Tunnicliffe (holding horse) with his sisters at Lane Ends Farm in about 1908.

At the Royal College of Art.
A picture taken in London about 1921.

Tunnicliffe as a young art student
at Macclesfield about 1917.

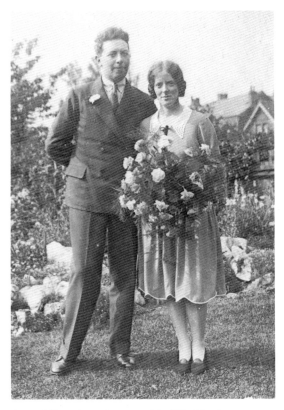

A wedding day picture with Winifred.

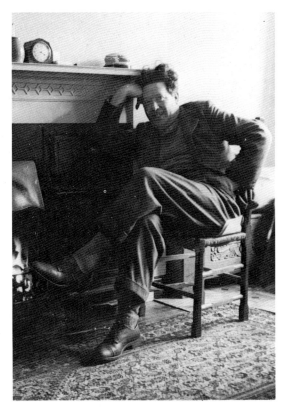

At Nicholson Avenue, Macclesfield,
in the 1930s.

nothing of it. For this William Tunnicliffe, father of Charles, was thankful. He was a shoemaker in Langley village. The Tunnicliffe children had numbered three until Charles was born. His sisters, Ann Emma, Florence and Ada were the survivors of five born to Margaret Tunnicliffe before Charles arrived on the scene. Two boys had died in infancy and now, at last, Margaret had a son, though with so many to share such a small house the problem of more adequate accommodation was one to be solved before long. A solution to the problem was really doubly urgent. William Tunnicliffe was advised by his doctor to seek a new environment, one in which he wouldn't be hunched at a workbench for so many hours of the day. William worked hard at his trade. A man with a wife and four children had to work hard. The work was telling on him and he looked for another way of life. When they heard that they might have Lane Ends Farm, consisting of no more than 20 acres at the village of Sutton Lane Ends, William and Margaret lost no time in looking at the place and making up their minds to move. Sutton Lane Ends was nearer to Macclesfield by perhaps half a mile, but still out in the clean air of the country. Margaret came of farming stock and knew what the business was all about, and she knew that as her children grew up they would be able to do their share. William, with a trade in his hands and the knowledge that farming had its built-in drawbacks, determined to take his shoemaking tools with him.

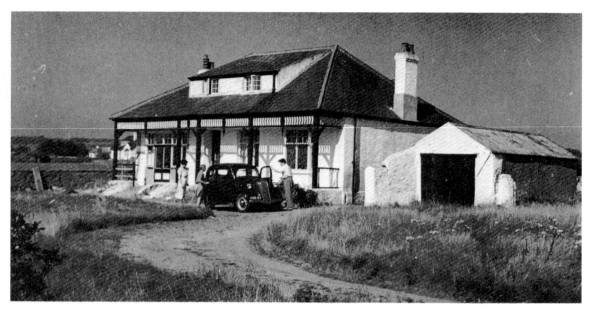

Shorelands in August 1947, a few months after the Tunnicliffes moved in.

Young Charles was eighteen months old when they moved from Langley to Lane Ends Farm, too young to remember the house in Langley or the family's removal to Sutton Lane Ends. His younger sister, Dorothy, was born at Lane Ends where Charles contracted pneumonia and had everyone thinking that he would soon follow his infant brothers into the grave. Margaret's more outspoken friends shook their heads and said knowingly that she might have raised girls but she wasn't able to raise a son. Some women then, as now, always believed that raising a boy was a more difficult business. The treatment for pneumonia was the standard one for the complaint at that time – boiled linseed poultice, a recipe, some would say, intended to kill or cure. When it didn't kill it often left scars on the back of the unfortunate patient. The forebodings of her friends had no noticeable effect on Margaret Tunnicliffe. She nursed young Charles through his illness, brought up her fourth daughter and found time for all the daily chores of a life into which the Tunnicliffes had been precipitated by their move. Young Charles had no choice but to reconcile himself to being raised in a household in which women predominated. Perhaps this is what brought him hurrying out on his father's heels to play in the farmyard and get a child's perspective on cows and pigs and the horse. When he was forty, Charles wrote a delightful account of these early years:

> What urged me to draw and paint in the first place I cannot say; what is it which compels one man to be a farmer, another a wheelwright, and another a driver of trains? ... When I was very young I scribbled shapes and marks which were supposed to be horses and cows.

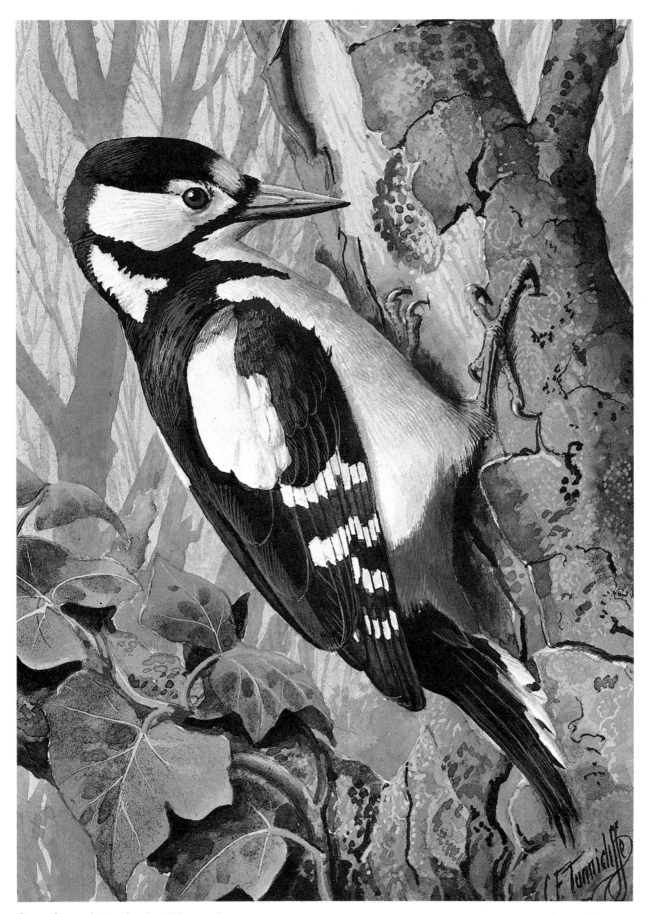

Great Spotted Woodpecker. Watercolour.

One of my earliest memories is of the occasion when my father erected a shed to house a cart and some implements. One side of the shed was made of wood, and was constructed of oblong-shaped panels framed up with thicker timber. The panels were most inviting, for had I not been given a fine, brand-new stick of chalk! The shed was duly creosoted and the panels dried out a nice dark brown colour, lovely! Chalk drawings would look grand on them! One day, on returning home, father found the whole side of the shed embellished with chalk drawings of horses, cows, pigs, hens, ducks, pigeons and heaven knows what else. In spite of the fact that my drawings were now recognisable as particular animals and birds, he was not at all impressed – at least, not in the way I had hoped. What made matters worse was the fact that my wooden art gallery was in full view of the road which ran past the farm gate. It required weeks of rain before the drawings were obliterated, and, in the meantime, threats and ominous warnings had been uttered concerning chalk and any reappearance of it. So for a long time the chalk lay low and, when I had exhausted all the available clean paper in the house, I had to content myself with pencil scribbles on the white-washed walls of the shippons and stables.

As I continued to deface the walls of the house and farm buildings, my Christmas presents became boxes of paints, drawing books and sketch blocks. I shall never forget my first sketch block – I thought it was a great invention: so flat and rigid, and with a beautiful clean sheet under each one I tore off. Alas, the sketch block did not last for ever, and after I had drawn portraits of the cows which gave the most milk, the big sow and the glowing Rhode Island Red cock, not to mention various dogs, cats, and a neighbour's bull which persistently broke through into our pastures, I came at last to the cardboard back of the block.

And so to school, where the drawing lessons were the bright spots in a less bright routine of reading, writing, arithmetic, history and geography. Drawing lessons were held three times per week on Mondays, Wednesdays and Fridays. On Mondays we drew from white painted wooden models of cubes, prisms and cones. I cannot remember of what the Wednesday lesson consisted, but Friday was the day, for then we had memory drawing and could do just whatever we pleased. So the drawing books became filled with all sorts of things; savage beasts, cowboys and Indians, and, of course, the inevitable farm animals.

As I grew older and stronger, more and more work on the farm fell to my lot. By the time I was ten years old I was up in the morning with the earliest, milking the cows. I also learnt to ride a horse and, although it was all bareback riding at first, I could never get enough of it . . .

My Country Book (1942)

Lane Ends Farm was a very old place with its steading and dwelling house in line. Although it was a mere mile and a half from the town of Macclesfield, the village was part of the rural landscape and had nothing to do with the smoke stacks and the manufacturing scene that was the silk town. Here there was room for a growing family and Lane Ends was a happy household. There were willing hands to do the work and six days to do it in, and on the seventh, time to go to St James's Church, part of the Sutton Lane Ends landscape in which the farm belonged. When he was old enough, Charles was recruited into the St James's choir

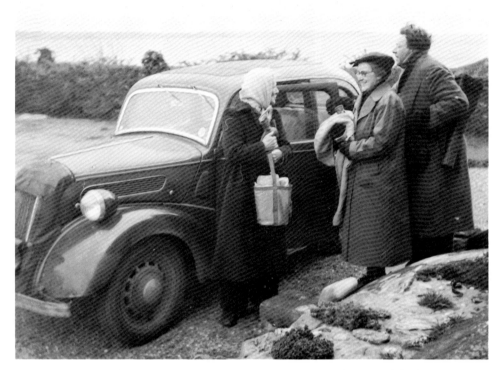

Setting out on a birdwatching expedition, January 1953. Charles (with telescope) and Winifred with their friend Mrs Hollowell, whose husband took the picture.

At work, Shorelands, January 1952.

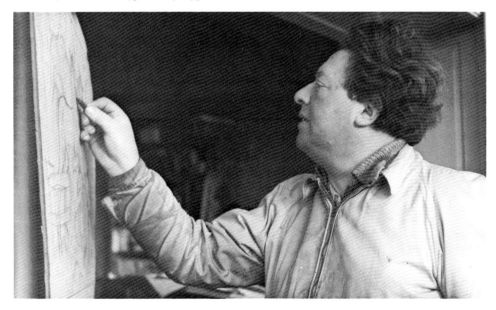

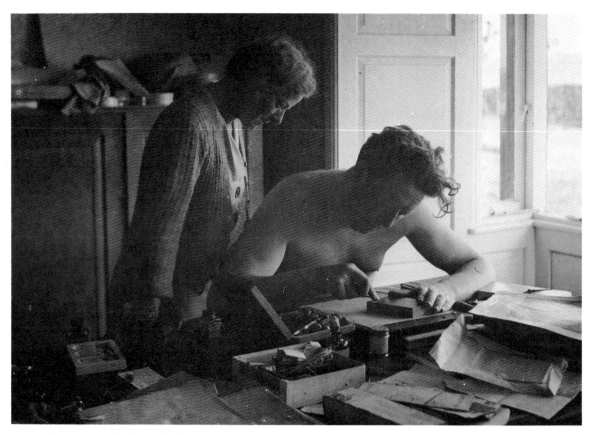

Engraving on wood, Shorelands, August 1947.

The Sick Cow. The figures in this early etching are closely modelled on William and Margaret Tunnicliffe.

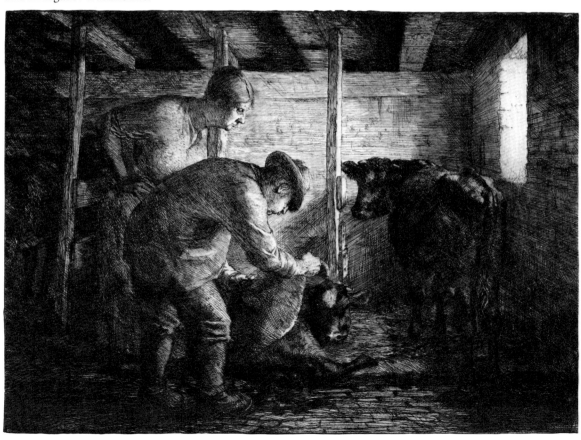

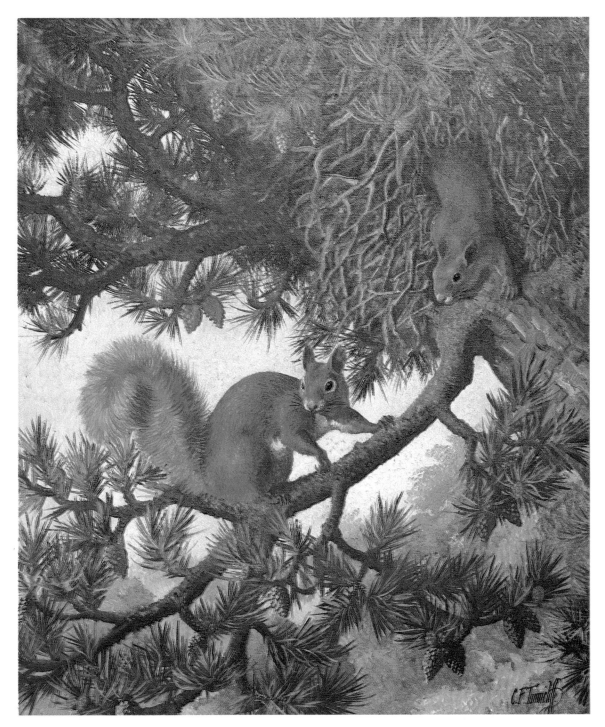

Red Squirrels. Oil on canvas.

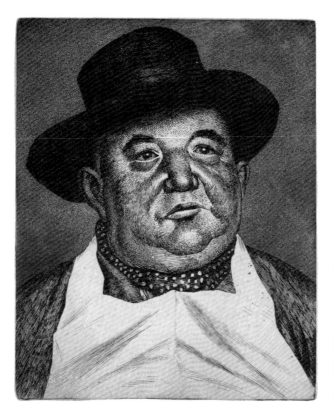

The Pork Butcher. Etching, about 1926.

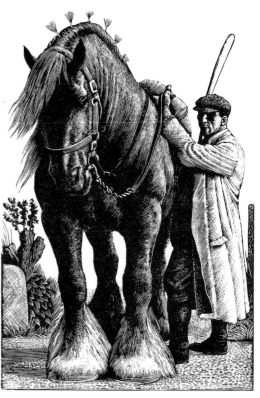

Stallion and Groom.
Wood-engraving, about 1941.

and sang treble in a 'seven-a-side' of fourteen choirboys who practised anthems, the Sunday list of hymns for morning and evening service, and carols at Christmas. Young Tunnicliffe was a well-behaved, rather solitary son of Victorian parents. Respectable families were held together by a proper sense of duty to the family. This involved tasks which mother and father allotted to each one of them and which were performed day after day, or week after week, without further instruction. Charles's younger sister, Dorothy, for instance, always black-leaded the range on a Friday. On Saturday without fail she was expected to clean the knives, rubbing them on a powdered block to resharpen them, and to make the rest of the cutlery gleam in the lamplight. Mrs Tunnicliffe knew these things would be done before the appointed day was out. The whole family knew it too, just as they knew when the darning would be done, the bed linen changed or the iron set on the fire for the ironing to be done. Charles, as well as the others, had his quota of cows to milk and his cans of milk to deliver before he went to school.

The Tunnicliffe economy was practically tied to the milking cow, though William continued to cobble, mend clogs used in the shippon by his wife and himself, and make boots for anyone who wanted them. His reputation was considerable and his boots must have been

The Forest of Macclesfield. Etching, 1929.

The Colt. Etching.

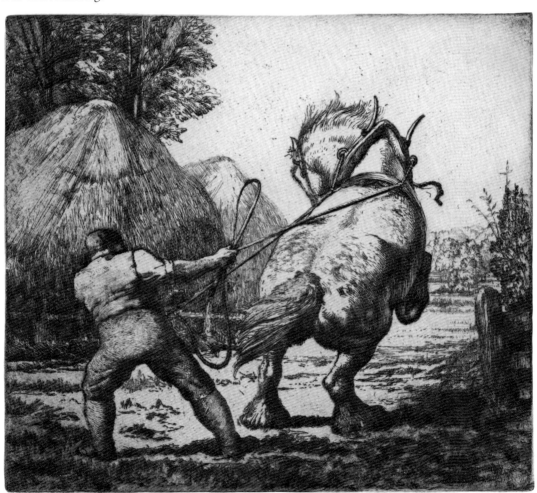

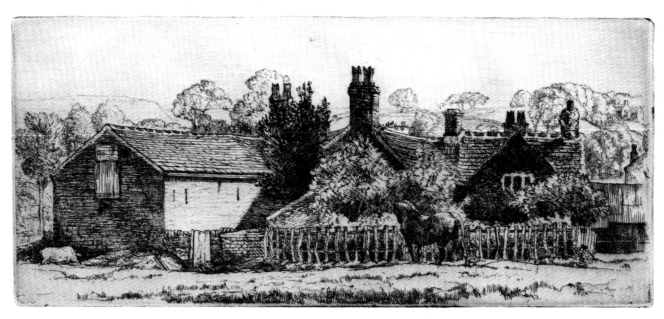

Kemp Croft Farm. Etching.

very good because when one customer emigrated to Canada he hadn't been out there long before he wrote to place an order for three more pairs. William dutifully made them and shipped them out to him. It seemed that in that particular part of the North American continent no one could make boots like those made in Cheshire.

At Lane Ends, as on nearly all small farms, there was little money to spare for outside help. Everyone turned to and worked at the hay once it was cut. In due course it was Charles who drove the horse-mower. He worked to cart the hay and fork it into the barn. There was always something needing to be done about even a small farm, but at school Charles was able to give attention to his drawing lessons. He drew the rooster crowing on the midden, the neighbour's bull at the fence with its head lowered and a baleful look in his protruding eyes, or cows as they jostled one another making their way through the gate from the yard. The drawings were greatly admired and Mr Buckley Moffat, Charles's 'sympathetic headmaster', soon realised that he had something of a prodigy on his hands. It was Mr Moffat who visited the Tunnicliffes and told them what he thought of young Charley's ability and how the boy might make something of his talent given the chance. William Tunnicliffe's reaction was probably not much different from that of a local farmer quoted by Charles in *My Country Book*: "Any dam' fool con wag a pencil, Charley, but it taks a good mon to muck a shippon out." Nonetheless, largely because Margaret Tunnicliffe was determined to see that Charles had his chance, it was agreed that his drawings should be shown to the principal at Macclesfield School of Art. The result was not just a place, but a scholarship, and Charles's formal training as an artist began.

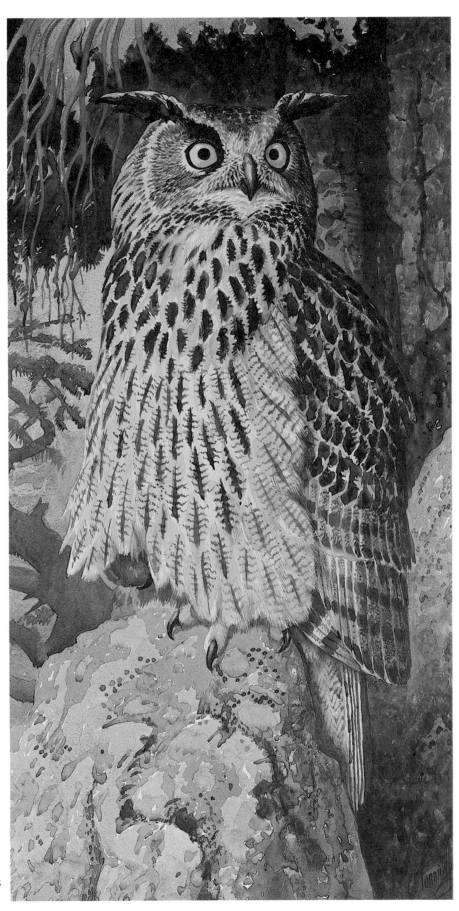

Le Grand Duc (eagle owl).
Watercolour. One of Winifred's
favourite pictures.

At Macclesfield he was in a very different world from that of the village school. Although his fellow students were interested in art he had little in common with them. He kept himself to himself as he had done at Lane Ends. He was always inclined to be a loner, completely absorbed in doing his own kind of work. He lived for art in an extraordinarily single-minded way. When he came home to do those tasks his father delegated to him he was always thankful when he could once again lay his hands on the pencil or charcoal and his sketch block. He never made time to stand and stare, as idle youngsters did, but stood to sketch the features of a familiar landscape, the steading, the church, the trees, or the animals in the fields. In the end the excellence of his work and his application in doing it prompted his Principal, Thomas Cartwright, to suggest how he might progress. His work was good enough to be considered by the Royal College of Art. Once again the Tunnicliffe family had to consider the consequences. It was plain that Charles didn't want the farm but no one had seriously considered his going to London to further his study. The Royal College sounded almost as impressive as Oxford or Cambridge, but what might the end result be? He might expect to come out with a teaching diploma but teaching was a living that paid not much more than farm labouring, and London was a formidable place, by all accounts, where people hardly knew their next door neighbours.

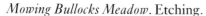

Mowing Bullocks Meadow. Etching.

The Mowing Machine. Etching.

Charles sat the examination for the Royal College and his last term at Macclesfield was over. While he worked on the farm and sketched the cows ruminating on the pasture his fate hung in the balance. If he didn't go on as he hoped he would have to think of something else. He had never at any time thought about going into industry. The silk-print business hadn't the slightest attraction for him. He looked about and wondered whether his horizon was to be the hill country of that part of Cheshire, or the drab streets of London, gables boarded and covered with garish advertising, busy thoroughfares congested by buses and lumbering brewers' drays. The war was newly over and the world was at peace. Skylarks ascended in Cheshire singing as they spiralled down again. God was in his heaven and all was right with this world but the music was different in London. Ex-servicemen limped along the gutters playing trumpets, trombones and tin whistles and holding begging tins. Too many people were looking for work. Whether young Charles thought much about it or not there had to be other promising young artists who had submitted their work and taken the examination, and some of them were certain to be better than average.

Most people who have sat an examination and waited for the result know the dead feeling between handing in the work and the day of judgement, but the Tunnicliffe family were too phlegmatic to live on their nerves. Charles recalled that no one was particularly excited when *the* letter came at last and the result was known. C. F. Tunnicliffe was informed by the Royal

The Harvesters. Etching.

The Old Quarry Road. Etching.

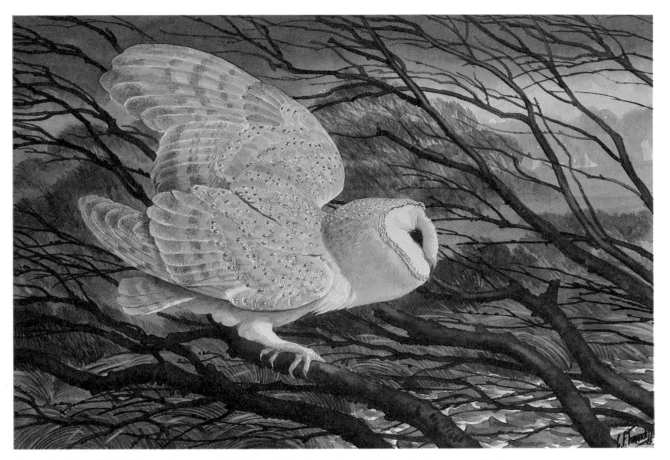

Barn Owl in a Gale. Watercolour, 1966. The original version of this painting was called
Gusty Twilight and was exhibited at the R.A. in 1953.

College that his work merited a scholarship. He would live in lodgings in London and would
receive the sum of £80 a year which would enable him to do so. A course at the Royal College
was a whole world away from the place where the cock crowed each morning, the cow
bellowed hollowly from the shippon and there was a metallic clang of milking pails and
churns. The Tunnicliffe parents must have wondered again about the youngster they had
raised and what made him so different from the boys of the village or the sons of farmers
round about. They impressed on him that he would have to work harder than ever. He
wouldn't like London. Even Charles himself knew this before he set out, but he also knew
what London meant. It meant being schooled in techniques only masters could demonstrate.
At bottom he was himself, the countryman born, the man with his feet on the ground. He was
going to London to improve his skills, leaving behind in Macclesfield not only his family but
two schoolmasters whose encouragement gave him his start. When, in 1925, Charles thought

about teaching, he applied to Buckley Moffat and to Thomas Cartwright for letters of reference. Their replies have a depth of sincerity which is still most moving:

Macclesfield School of Art 10 July 1925

I have pleasure in writing this testimonial for Mr Charles F. Tunnicliffe, ARCA, whom I have known for many years and we, in Macclesfield, have had a student of unusual ability above all his colleagues.

From 1915 to 1921 a day Free student, Local scholar, the best Art student who has passed through this School, gaining honours and awards in examinations, and exhibiting Drawings, Paintings in oil, Water Colour in exhibitions, moreover he has had a training as a draughtsman, studied many subjects such as:– Architecture, Perspective, illustration, etc. Mr Tunnicliffe has passed the Board of Education examinations with distinction, gained a

Winter Dawn. Etching.

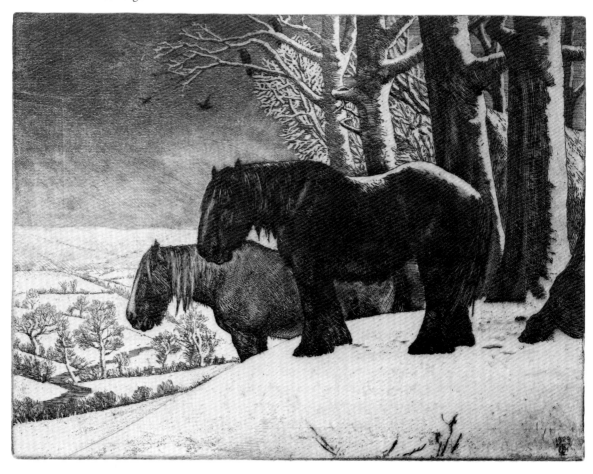

local scholarship afterwards, placed first and awarded a Royal Exhibition and County Scholarship tenable at the Royal College of Art, awarded the Diploma of the College and Prizes for his work.

I recommend him for any appointment, he is an exceptional artist, influences other students, has assisted me in teaching at this school. He will go a long way in subjects of Painting and allied work in which he has given all his life and ability.

<div align="right">

Thomas Cartwright ARCA (Lond)
Principal

</div>

From the Head Teacher
St James' C.E. School
Sutton, Macclesfield. 8.VIII 25

Mr Charles F. Tunnicliffe spent the whole of his Primary School life at Sutton St James' School. He was an apt and enthusiastic pupil.

More capable judges than I will bear testimony to his artistic ability but no one has a more complete knowledge of his work and aspiration.

He loves work and is never daunted.

For a brief period he deputised at the Macclesfield Grammar School for his art master.

<div align="right">

Yours faithfully,
Buckley F. Moffatt

</div>

❧ 3 ❧

London Scene

"LONDON WAS SHIMMERING under a haze of fine weather which had outstayed its welcome when I first arrived there. Euston was dingy, dusty, and bleak, and the grass in the parks broke and powdered under my feet. Smells of petrol and tar were everywhere, and I had not been in London more than an hour when I was wishing myself well out of it. What a fool to leave those fresh fields and lovely hills, the familiar faces and friendly animals! I would have given anything to be astride the black mare which I had helped to break in and which I was so fond of riding. That first month in London was a bad one: I was terribly homesick, and, to make matters worse, I was living in a tiny bed-sitting room, in Earls Court which was anything but homely and, emphatically, not my country.

"In time, however, the awful nostalgia wore off as I gradually became absorbed in college work. During that first term I discovered the Zoo and the Natural History Museum, and any opportunity found me at one or the other of those delectable places. My sketch book soon became full of animal and bird studies from both stuffed and live specimens, but before long I became critical of the art of the taxidermist, and concentrated more on the living animal, using the museum only as reference for plumage or anatomical details. In the college itself, the painting school was dominated by the study of the human figure and the compositions demanded were figure compositions. So I studiously drew and painted from the life, but for my compositions I always made use of my farmers and farming scenes. If a composition was required with 'Summer' as its subject, I could think of nothing but the mowing and carting of hay. 'Winter' meant the hungry cattle and the big knife cutting into the hay stacks, a pig-killing scene, or a group of rough-coated colts with their tails to the weather. And while those students who talked much rolled out the names of Cézanne, Picasso, Gauguin and Matisse, I was more interested in the works of certain other masters – Piero della Francesca, Pieter Breughel, Hans Memlinc, Albrecht Dürer and, nearer to our own time, John Constable, Thomas Girtin, and John Sell Cotman. We all had our gods.

"Every vacation from college I spent at home on the farm, and much of the spare time

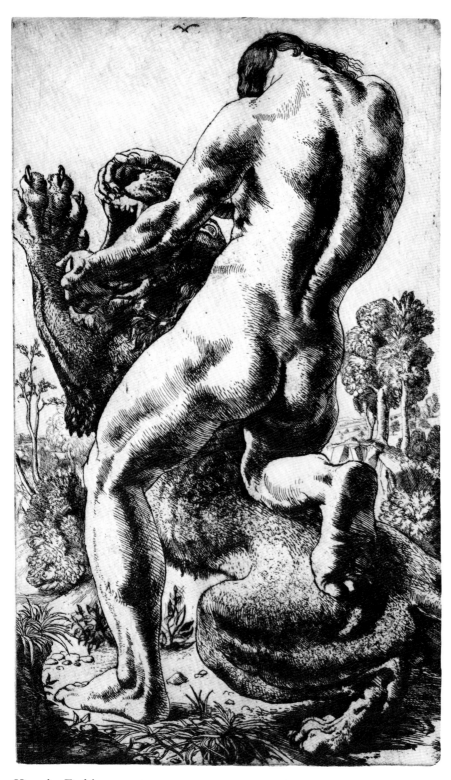

Hercules. Etching.

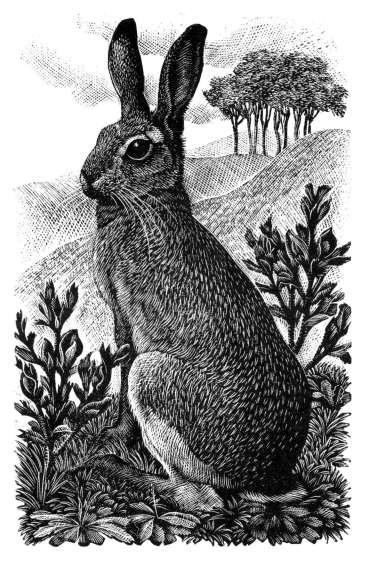

The Hare. Wood-engraving.

from the work of the farm was utilised in making studies of landscape, animals, and people to be employed in compositions on my return to college. 'Absence makes the heart grow fonder' so it is said; and I was quite sure, on my several returns to the farm, that there was no country like my own corner of east Cheshire. On a summer Sunday evening I often saddled the black mare and rode into the hills to sit for hours gazing over the forty miles of Cheshire Plain where, away to the west, the mountains of Wales rose in dim blue ridges, one behind the other, while the mare cropped the roadside grass and the sound of the church bells came faintly from the village below . . .

"During my fourth year in London I joined the College engraving school, and soon became absorbed in the art of etching. The first exercise was to copy a head by one of the masters of etching. I chose a small self-portrait by Rembrandt, but my second etching

portrayed four farmers and two horses leaving the hayfield. Subsequent plates also reeked of the farm and the farming life. Rembrandt, Dürer, Paul Potter and Millet were now my masters. For seven years I lived in London, etching many plates and, during the latter part of my stay, publishing some."

My Country Book

At the Royal College Charles found his fellow students a mixed lot, if a fair cross-section of the youngsters of his generation. They came from all parts of the country and very different backgrounds – well-to-do youngsters from the West Country, a rough Yorkshire lad, Northerners who spoke with strange accents, and Southerners who would raise their eyebrows and smile in a superior way at a baffling word of dialect. Charles recalled that the average student, if there was such a being, was a conformist by modern standards. Perhaps these post-war students were aware that they had been fortunate in being born too late to be eligible to fight, and fortunate to have work to do and a roof over their heads. A scholarship that provided £80 a year for a man's keep was not a very generous one, but bed and full board could be had for a pound a week or sometimes less.

Red Squirrel. One of a small number of animal studies kept for reference at Shorelands.

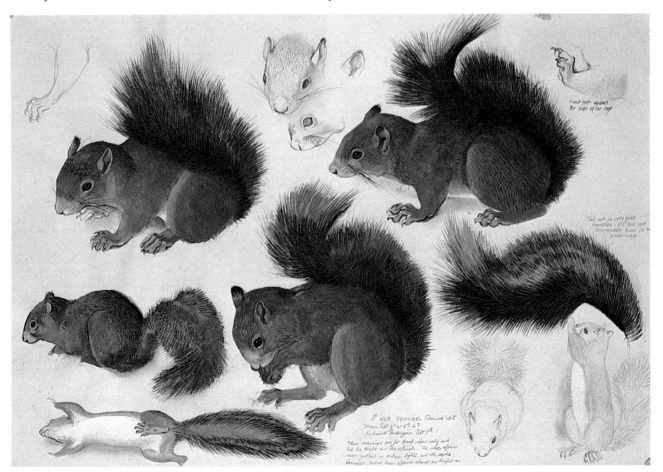

Rabbits. Aquatint, 1929.

The Sitting Hare. Etching.

At the Royal College there was an unabated insistence on work and basic principles. Students were taught that the Masters had worked harder than anyone else. Only their complete devotion to their subject had produced the great works of Cézanne, Matisse, Breughel, Dürer, Constable, Turner … The 'leading light' at the Royal College when Charles Tunnicliffe went there was William Rothenstein, a master painter in his own right. Others for whom students in the different schools worked were Constable Alston, Schwabe, Frank Short, Malcolm Osborne, and Professor Pyke who was fond of asking his class, "Tell me, where is fancy bred? Or in the heart or in the head?" Etching particularly appealed to young Tunnicliffe. He was taught by Sir Frank Short and subsequently by Malcolm Osborne. Later on he was able to augment his £80 subsistence allowance by working as an etcher and the training he had had as an engraver stood him in good stead much later when he left the College and became a wood-engraver.

Back at Lane Ends, William Tunnicliffe was no longer able to do his share of work. This made problems for the women yet no one would have dreamed of asking Charles to give up his studying and come home. It is doubtful that he would have done so. He saw a better life ahead of him. The day when he had contemplated being a farm boy was gone. The world seemed to beckon.

Among those who beckoned was Malcolm Salaman. Charles had been fortunate in meeting this self-appointed patron, or 'Daddy of the etchers' at the Royal College. Malcolm Salaman was well-known and respected in the art world. He had many contacts with publishers, critics and art dealers likely to be interested in the work of a young school of etchers. Etching was the fashionable thing in art, and experiencing a boom as a result. Anyone on the fringe of the art world with a little money to spare bought etchings as an investment. The same thing happens with the work of young painters of course, but in the 1920s etchings seemed an even more inviting prospect and a better hedge against inflation. Those who could, etched their plates whenever they were free, and did their work in their digs as Charles did. Once the plate was ready for the acid it was taken to the Royal College where there were facilities for 'biting' it. Charles went to tea with Malcolm Salaman on Sundays and through the offices of the benign old Jew arranged to supply so many etched plates a year for publishers with whom Salaman had contact. This work could bring in about £100 a year to the artist (equivalent to at least £1000 today). There was no stipulation on the part of the publishers as to the subjects to be engraved. It was enough that they were of a high standard of competence. The world would pay for the thing it fancied, but of course when the plate was handed over, the copyright went with it. It was up to the publisher how and where he sold the prints and how many were offered. One of Charles's best etchings was of a bull, a great, surly beast that lowered his shaggy head and looked as fearsome as any brute in the Madrid bullring and twice as heavy. *The Bull* sold in America at a much higher price than it fetched at home, and many times the fee Charles and his fellow etchers received for the plates they parted with. Malcolm Salaman, to give him his due, took no commission from the young etchers whose work he managed to place for them. He was instrumental in the first publication of a portfolio of etchings bearing the name C. F. Tunnicliffe offered by H. C. Dickins and Co. of London. Dickins also had an outlet in America. It is the hope of reward

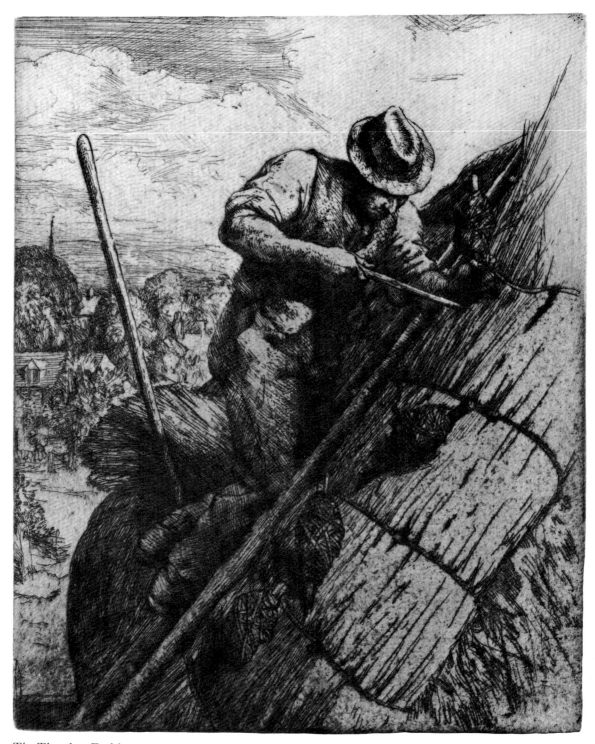

The Thatcher. Etching.

that sweetens labour, someone has said. Charles was in no position to scorn reward. He had laboured long for it, both at the College and in the small room of his lodgings at Earls Court.

By the time most young men reach the age of twenty they have had a number of girlfriends and some have, by this time, lost count of their minor affairs and liaisons, but Charles was no sort of ladies' man. He had paid no attention to girls when at school. He had had few friends at this time and his sister would say that when she tagged along behind he regarded her as a nuisance. He had lived in a house of women for a good part of his life and seemed to be far from charmed by their company, until in his second year at South Kensington Winifred Wonnacott arrived on the scene. Winifred's work had been submitted for consideration by the College, just as Charles's had been. She too, sat the examination and won a scholarship, and here she was, over from Northern Ireland to study Art. She had been born in Belfast and spoke with a soft Irish accent that quite bewitched young Tunnicliffe when he first spoke to her. Winifred was of English parentage, however. Her father came from Devon and her mother was a Londoner. Mr Wonnacott had gone to Belfast to put right the affairs of a branch of the company for which he worked and had remained to raise a family there. For

Sitting Hare. Oil on unprimed cloth (1937/8). This was a favourite painting. It was displayed in the sitting room at Shorelands.

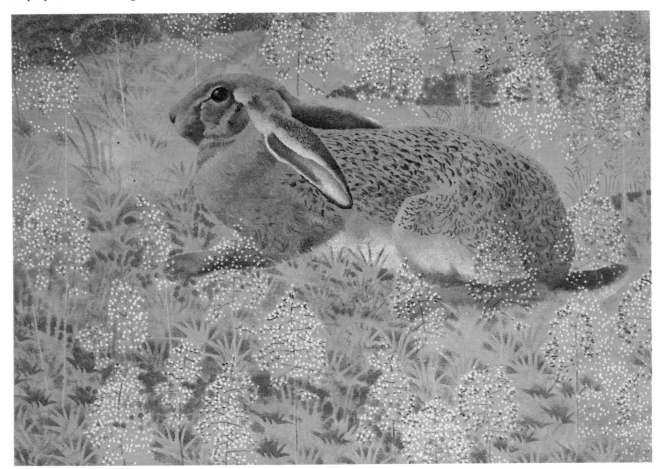

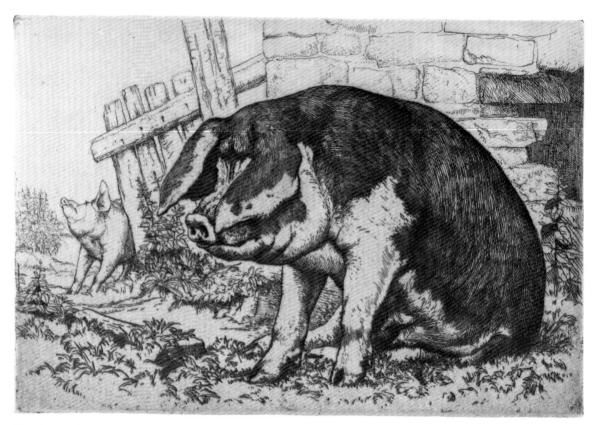

The Spotted Sow. Etching.

Pig Slaughter. An early woodcut from about 1934.

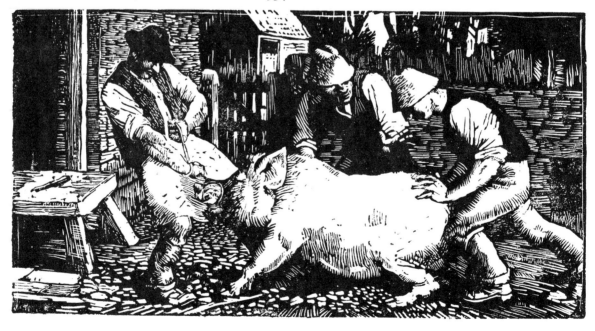

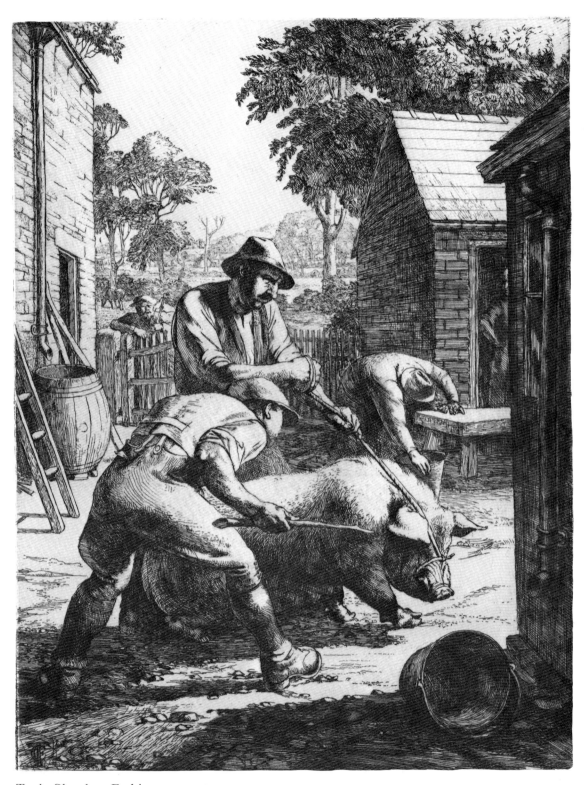

To the Slaughter. Etching, 1925.

Charles life in London had suddenly taken a better turn. All at once it was bearable and pleasant. He enjoyed the ready laughter and the leg-pulling his friendship with Winifred brought. Winifred paid particular attention to craft as well as sculpture and design, subjects she later on used in her job as an art teacher when she went north. Charles took her to Cheshire to meet the family and she stayed at Lane Ends. She got on well with the Tunnicliffe women from the start. They saw her not only as a strikingly good-looking young woman but a very gentle, sympathetic person. She didn't meet William Tunnicliffe. He was by this time completely confined to his bed, and indeed they never did meet. Winifred and Charles went back to London and their respective courses. Charles lost no time in getting his head down to work as hard as ever. At the back of his mind were obstacles he would have to overcome if in the end he was to avoid becoming simply an art teacher. One of the imponderables looming nearer all the time was what would happen at Lane Ends when his father died. Charles's elder sisters had their own lives and were married. It had been a milestone when the Tunnicliffes had graduated from being tenants of the small farm to being freeholders. There was no kind of boom in farming. On the contrary, times were getting harder. Land prices were no more encouraging. In Wales, bordering Cheshire, hill land for sheep grazing sold for little more than ten pounds an acre. The eggs and butter the Tunnicliffe women had to offer would perhaps bring a shilling and sixpence – a dozen eggs or a pound of butter – and certainly no more.

Charles would have been disappointed had anything compelled him to leave London and part company with Winifred at the end of his course. But the high standard of his work as an etcher now earned its reward. He was offered a further year's scholarship to study etching exclusively. This came when he received his diploma on the completion of his three years. He wrote home to tell them how he had fared, a very short letter in which he didn't waste words. His sister Dorothy remembers the letter by heart. It wasn't hard to remember for it said 'Passed with distinction. Charles.' Perhaps he had drafted it intending to send it as a telegram but found he hadn't a spare sixpence, or perhaps he was off out to sketch something at the Zoo. He certainly didn't look for the fatted calf when he came home to Lane Ends. He had successfully achieved what he had set out to do, and another year would perhaps show him how to steer his course. He had shared digs with at least one engraver who would make a name for himself, Eric Ravilious, who later on became an official war artist and died on active service. Ravilious had come from Eastbourne School of Art and after his time at the Royal College was notably associated with the Golden Cockerell Press and recognised as a very fine wood-engraver. Tunnicliffe's deep involvement with etching seemed to leave him with few recollections of his contemporaries. Most of the people he remembered he never encountered again. Art is always a difficult course for anyone hoping to survive by commissions, for commissions come only with time and in the slow process of making a name. A great many promising young men sank without trace in the sea of industry and many accepted anonymity in the teaching profession. Teaching was a profession Charles hoped to avoid, a business he felt might curb his talent. The profession was, however, somewhat eager to gather him in, whether he really wanted it or not. One day the principal of Woolwich Polytechnic called to say that he was in a fix. A member of his staff teaching Art had fallen ill, or for some reason

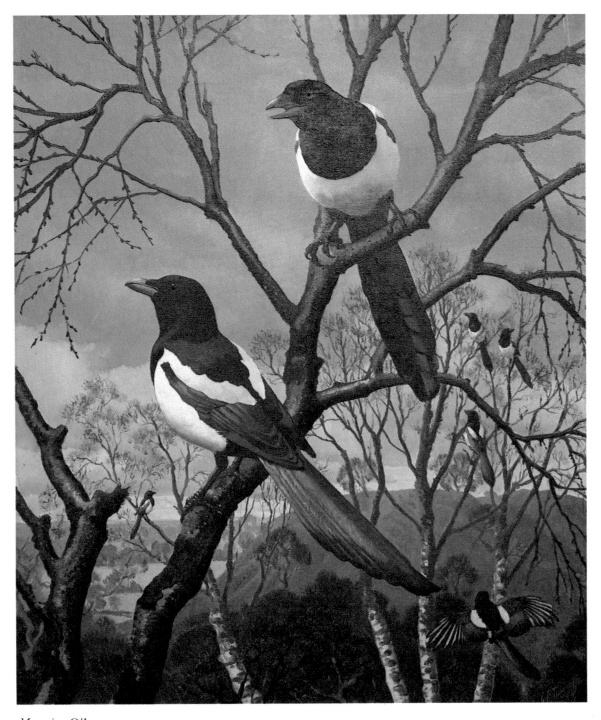

Magpies. Oil on canvas.

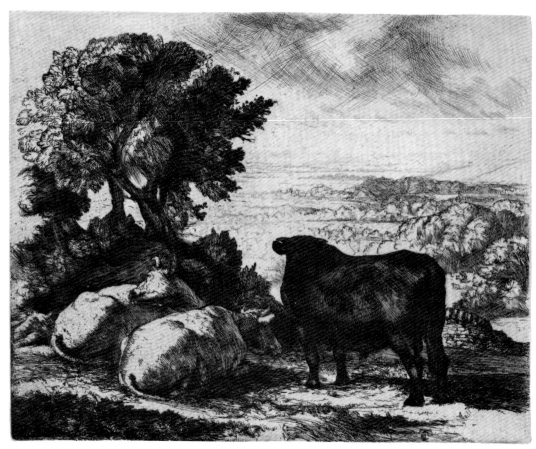

The Cheshire Plain. Probably Tunnicliffe's most famous etching.

The Thief. Etching.

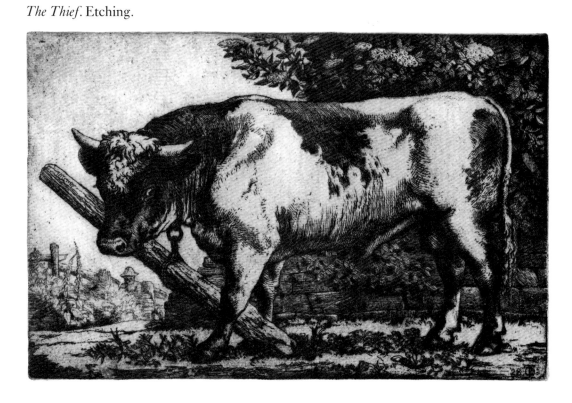

had been compelled to give up. Someone was urgently needed to fill the post, full or part-time. Charles had just come to the end of his final year at the Royal College. He calculated that he could survive in London if he combined teaching with etching and commercial work of some kind. He decided to accept the offer, become a part-time art teacher and move into digs at Walham Green to be nearer the Polytechnic. There he began to teach everyday practical stuff – design and poster work. There was no scope for those subjects in which he had shown outstanding ability at the Royal College – etching, drawing the animals of the farm. It was a case of keeping body and soul together at a time when the industrial depression was at its worst. Before long there would be hunger-marchers plodding to London from the North and from Wales.

William Tunnicliffe died in June 1925. Two years later, Margaret Tunnicliffe sold Lane Ends and moved out. Charles had made many minor sketches of the farm and the landscape. He had made hundreds of pencil and ink drawings of all the pigs, cows, horses, chickens as well as crows and magpies that came about the place. Much though the thought of working on a farm now repelled, he couldn't deny the importance of his formative years there. In a decade or so the world outside would acknowledge that he was able to draw farm animals as few others could. He would later graduate as a wood-engraver to become a member of the Academy, no small achievement for a sometime farmer's boy.

In 1928 Charles finally decided to leave London, and have done with part-time teaching. He returned to his native place and the town of Macclesfield. When Winifred left the Royal College she had found a post as a peripatetic teacher of art in the Manchester area. It was already in the minds of Charles and Winifred to marry, and in order to let his future in-laws see the kind of man she had chosen Winifred took him home to Belfast. Charles was almost certainly a little apprehensive about the Wonnacotts. They were a large family and they were non-conformists, devoted to their church. Charles told his father-in-law to-be that he had no money, and if an artist was to be judged by the number of pictures he sold, he wasn't selling any. This was typical of the young man. He preferred understatement. He probably didn't bother to mention that he had bought a house for his mother from his earnings, and he wasn't finding it difficult to get a living, even if he wasn't using his diploma. The Wonnacotts were probably better informed on what Charles had in the way of talent through their daughter, than by anything Charles had to say. They gave him their blessing. Charles and his fiancée went back to Cheshire. They were later married in the Methodist Church at Whalley Range in Manchester.

Winifred found a teaching post closer to Macclesfield and Charles devoted himself to his commercial masterpieces, and masterpieces of a special kind they were, and in great demand by the firms who paid for them. Graphic art work was just what was needed by the manu-facturers of cattle food, seed dressings, fertilisers, veterinary products and so on. Charles was well-equipped to provide the work. Anything he couldn't draw from memory he could find an excuse to seek out and sketch. At Lane Ends the cows had been Shorthorns. He now had to draw and paint Ayrshires with finer horns, pied Friesians, blue-tinted Holsteins, red and white Herefords or Lincoln Reds. The hens they had kept at Lane Ends had been the usual midden-scratching cross-breds, but now, for the makers of layer-meal, he needed to draw the

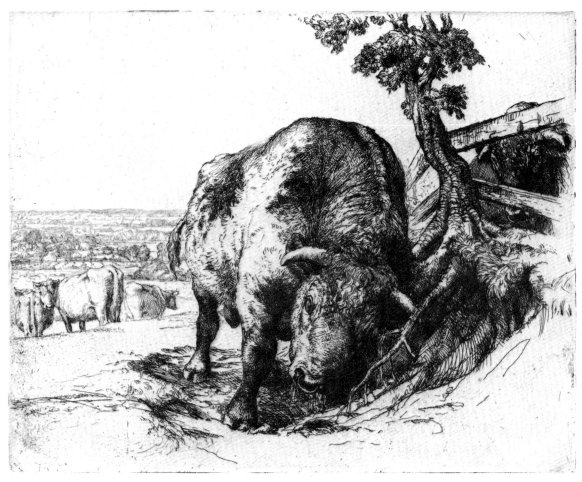

The Bull. Etching.

The Duel. Etching.

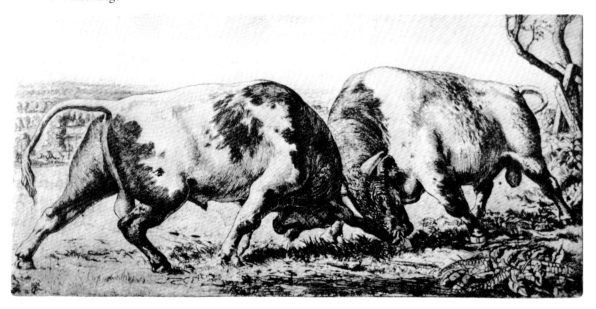

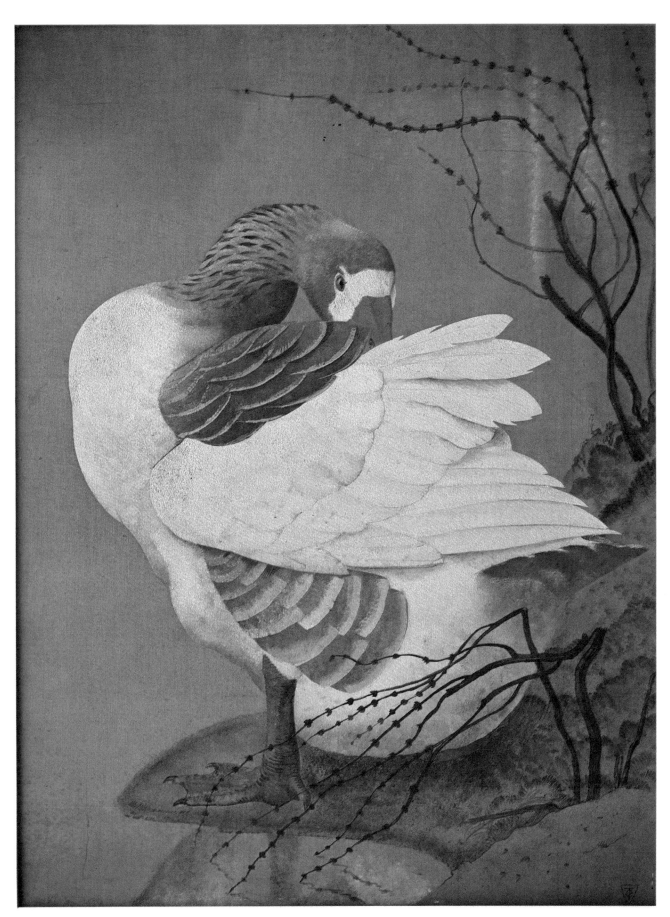

The Gander. Oil on unprimed cloth (1937/8).

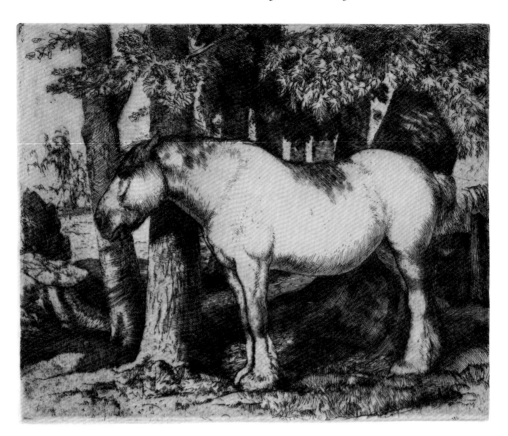

The White Horse. Etching.

Winifred. Etching.

Malcolm Salaman. Etching.

Rhode Island and there were people who wanted to see the Buff Orpington, the Wyandote or the little Black Minorca, breeds that are hardly anywhere to be seen today. Charles found them and drew them. His pigs at the trough pleased the breeders and helped sell patent mash mixtures. Cumbrian shepherds nodded their heads to see the Herdwick sheep at the dipping pen or being shorn at shearing time. As Britain's agricultural industry became more efficient, new types of advertising for farm products were required. The day of the quack's patent cattle drench was all but at an end. Farmers needed to be assured that an advertiser knew what he was talking about. Illustration had to have a certain authority to influence the customer. Charles knew the farmer as well as the subjects he was asked to provide. He gave the dog biscuit firm portraits of living dogs, and the dogs gambolled across the grass or slept on sunlit ground. His Border collies were genuine Borders. His wire-haired terriers yapped and his spaniels looked like judges in long wigs. Dogs in Tunnicliffe advertisements had obviously benefited from their condition powders. In this work Charles provided every subject he was asked for in line and wash and with the graver, in due course, for he did some particularly good wood-engravings for Bob Martin's. Soon the more important companies advertising their work in colour wanted the art signed – painting by C. F. Tunnicliffe. Charles initialled and signed his work. Most of it already had his signature upon it, whether he added his name or not.

(below and overleaf) Commercial wood-engravings for Bob Martin's dog foods done in the late 1930s.

4

The World of Henry Williamson

THE ACCLAIM THAT greeted Henry Williamson's *Tarka the Otter* established him as a nature writer of some considerable stature. When Charles Tunnicliffe offered himself as a prospective illustrator of that book (at Winifred's suggestion) he willingly became involved in Williamson's work as a whole. There began a phase of Tunnicliffe's career which he looked back upon ruefully, wishing he had had nothing to do with a very difficult and sometimes disturbed man. What he remembered of their association tended to be the shock of their clashes, which he put down to the insensitivity of Williamson in dealing with people. Williamson was a sensitive writer and a gifted one, but he could display an insulting indifference to what others might think, feel or know about any subject. Yet, when Tunnicliffe and Williamson first got together, Williamson could not praise Tunnicliffe's talent enough. In the end, their relationship deteriorated to the point that the normally phlegmatic young Cheshire man could tolerate it no longer. Their collaboration inevitably resulted in an involvement in Williamson's romantic attachments and this impinged not only upon Tunnicliffe's work but his domestic life. Williamson began to burden both Tunnicliffe and his wife with his unhappy situation. He bombarded both of them with correspondence, letters half about the work Tunnicliffe was doing and half about his own unhappy state of mind.

The Tunnicliffe-Williamson partnership came about a few years after Williamson had been awarded the Hawthornden Prize for *Tarka the Otter*. Charles greatly admired the book and made some aquatints of the otter which he sent to Putnams. The idea of publishing an illustrated edition appealed to both publisher and author though wood-engravings, not aquatints, were preferred. Putnam's also proposed to re-publish three other books of Williamson's, *The Old Stag*, *The Lone Swallows* and *The Peregrine's Saga*, uniform with the new, illustrated *Tarka*. Charles was invited to meet the publisher. Things were now on the move. Soon Williamson himself proposed a meeting and Tunnicliffe set out for North Devon, arriving there on a Saturday in May to be greeted very briefly by Williamson who immediately got on the train Tunnicliffe had left, waved him goodbye and departed to

Rough pen and ink sketch for the cover of
Tarka the Otter.

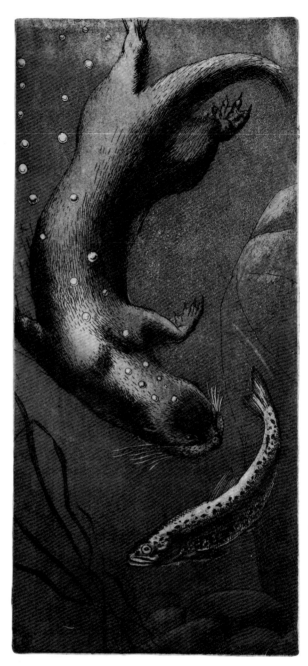

A historic aquatint, one of Tunnicliffe's original
sample illustrations for *Tarka the Otter*
rejected in favour of wood-engraving.

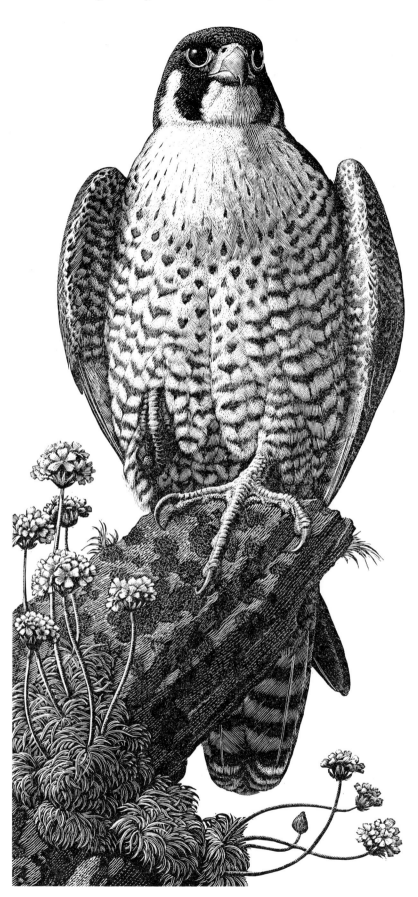

Peregrine. Wood-engraving, 1947.

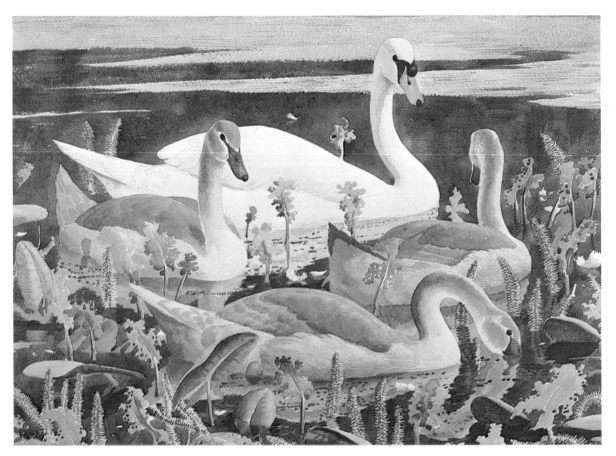

Capesthorne Family. Watercolour. Exhibited at the Manchester Academy, 1946.

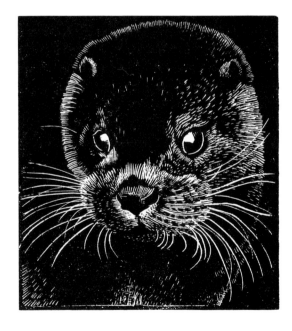

Tarka (all the small wood-engravings in this chapter come from Henry Williamson's books *Tarka the Otter*, *The Lone Swallows*, *The Old Stag*, *The Star-Born*, *The Peregrine's Saga* and *Salar the Salmon*).

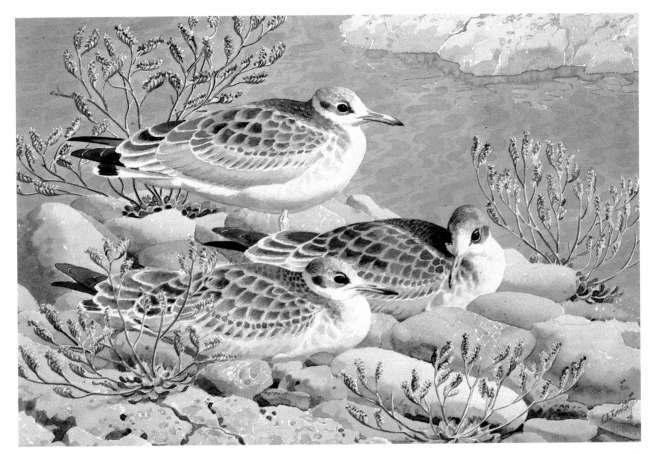

Juveniles (black-headed gulls). Watercolour exhibited at the R.A. in 1948.

Barnstaple. Ann Thomas, Williamson's secretary and general factotum, took Charles to Shallowford where he was received by Mrs Williamson. This was certainly not the sort of reception he had expected. He went to bed that night without meeting Williamson, and the following morning sat down and wrote a letter to Winifred back in Macclesfield to tell her how things had gone so far:

When I arrived at Filleigh Ann Thomas and Henry were at the station. Henry travelled on the train to Barnstaple to see about his car so I only had time for a few hurried words. Said he must see me later. Went down to Shallowford with Ann Thomas. Had late dinner with her and Mrs Williamson and spent the rest of the evening playing darts and skittles. Henry didn't turn up so we all went to bed. He must have come in later as he brought the car home but he hasn't got up yet. It's now 11.30 or 12 o'clock and I haven't seen the great man yet! He seems to have been very busy lately putting up shelves and making tables all of which he has done quite well. He has installed a carpenter's bench similar to the ones at school and has quite a good collection of tools. The kids, two boys and one girl are quite amusing. The eldest, aged 6, has just called his sister, aged 3, a 'bloody fool' for knocking the other brother off a chair. No sign of Henry out of bed yet, so I am going to the post.

[57]

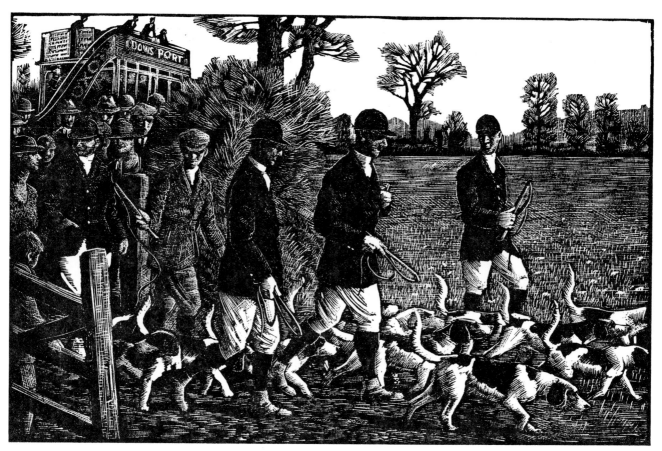

The Meet.

Later the 'great man' took over and entertained his guest to Wagner played 'full blast' and without respite. Between whiles he told Tunnicliffe what he felt about his own choice of music, and composers like Bach and Beethoven, who were all right for intellectuals. He had no time for soothing chords and delicate airs. Life was turmoil and trauma, it seemed. By contrast he praised the work of Richard Jefferies, and *Bevis* in particular, which he considered some of Jefferies' best work. Tunnicliffe disagreed. He was particularly fond of the work of Jefferies but would have 'kicked Bevis's backside'! It hardly mattered. Williamson had opinions he didn't expect to be questioned by a farmer's son who spoke with a Cheshire burr. He had probably thought nothing of the fact that already some of the young man's work had been bought for the National Gallery, Stockholm, and by the Victoria and Albert Museum. Tunnicliffe had come to be shown the world of Williamson, not to presume to tell him that Wagner was loud and violent and Bevis was a prissy lad – the least believable character Richard Jefferies had created, apart from *The Story of my Heart*! (Oddly enough Williamson himself cherished the same ambition to be a novelist and had no more success than Jefferies, to whom, incidentally, he dedicated *The Lone Swallows*.)

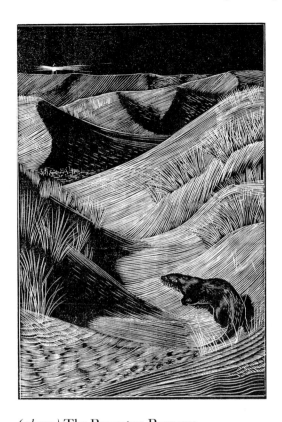

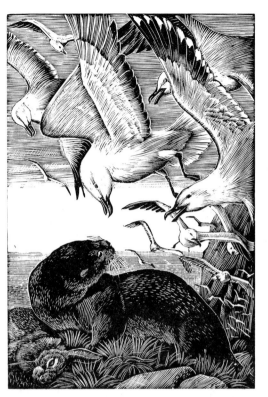

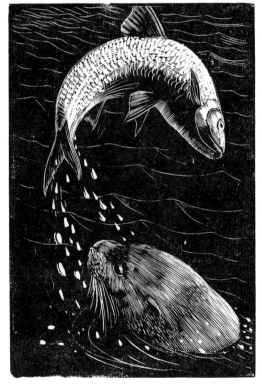

(*above*) The Braunton Burrows.

(*above right*) Gulls mobbing the otter.

(*right*) The leaping dace.

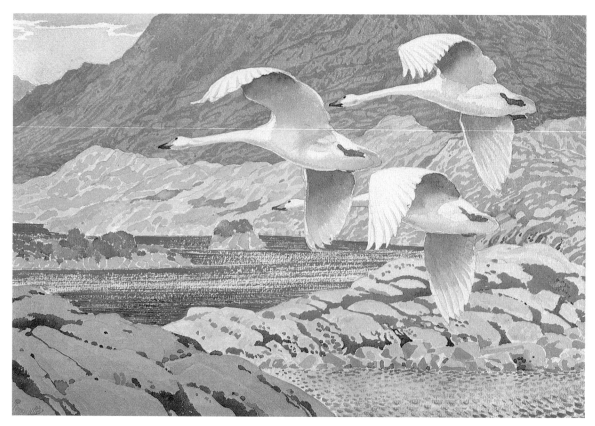

In Sutherland. Watercolour. Exhibited at the Manchester Academy, 1943.

Tunnicliffe returned to Macclesfield armed with enough reference sketches and notes to begin the task of producing roughs for *Tarka.* Williamson wrote suggesting that Tunnicliffe came down for the joint meets of the Cheriton and Dartmouth Otter Hounds and sent the calendar of the six meets. The official card told Tunnicliffe that, 'water permitting', the packs, hunting on alternate days, would visit New Bridge at Barnstaple on the 18th of July, Umberleigh on the 19th, Portsmouth Arms on the 20th, Town Mills, Torrington on the 21st, Beaford Mills on the 22nd and New Bridge, Dolton, on the final day, July 23rd. A 'cap' of 2s 6d was expected from non-subscribing followers. In order to minimise the danger of accidents, cars following the hunt were requested to draw up on one side of the road only. Williamson repeated this information on a second postcard and added that Charles ought to try to get down for these meets, as 'everyone' was there. Charles brought Winifred down with him on this occasion and went off with Williamson to see the real thing, as custom ordained, in the country of Tarka's death. He recalled a lady with a booming voice, and a great enthusiasm for inspiring others, telling the world in general, "I think we shall have blood today!" Greatly encouraged, the pack moved off and 'Captain' looked for Tarka in the tree roots. Alas for the hopes of the tweedy lady, there was no blood that day. The non-

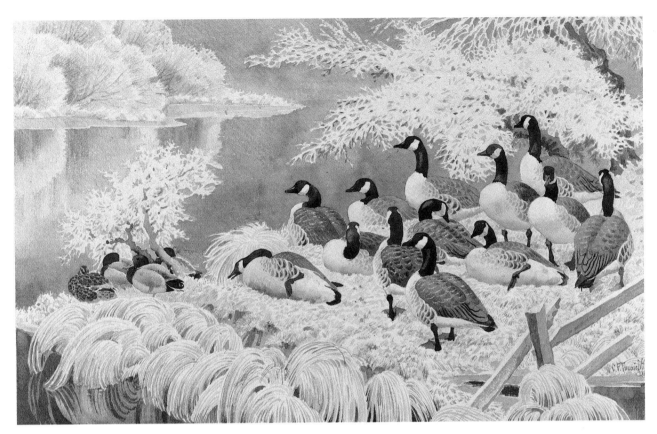

Hoar Frost on Mereside. Watercolour, 1941.

subscribers had paid half-a-crown for nothing. Later in the week the object of the exercise was achieved. 'Deadlock' closed on 'Tarquol', the whips lashed thin air. The Huntsman waded in to rescue the remains of a wretched otter, hard to find in the mêlée of snarling, yelping hounds. Tunnicliffe hurried forward to take a photograph, which would be the best reference for what were fleeting seconds in which the otter was torn apart. Williamson seeing him with the camera rebuked him. "Get sketching, Tunnicliffe!" he yelled above the sounds of slaughter. Williamson expected instant sketches. As it happened the snapshots did not come out and Tunnicliffe relied on his photographic memory which served him just as well. 'Deadlock' trailed home, the whips floundered and righted themselves, and followers reminded one another that they would have to cut another notch on their staves. It wasn't every day that they had blood. Tunnicliffe didn't remember whether the lady with the booming voice was there at the kill or not, but there were certainly other ladies and gentlemen with staves ready to make a stickle and guarantee the otter's death. Tunnicliffe drew them as he remembered them, graven-faced men, and not exactly gainly women in heavy tweed skirts and thick stockings, looking as sympathetically upon the death of the otter as women who knitted by the guillotine. Tunnicliffe was no kind of sentimentalist or anti-bloodsport man.

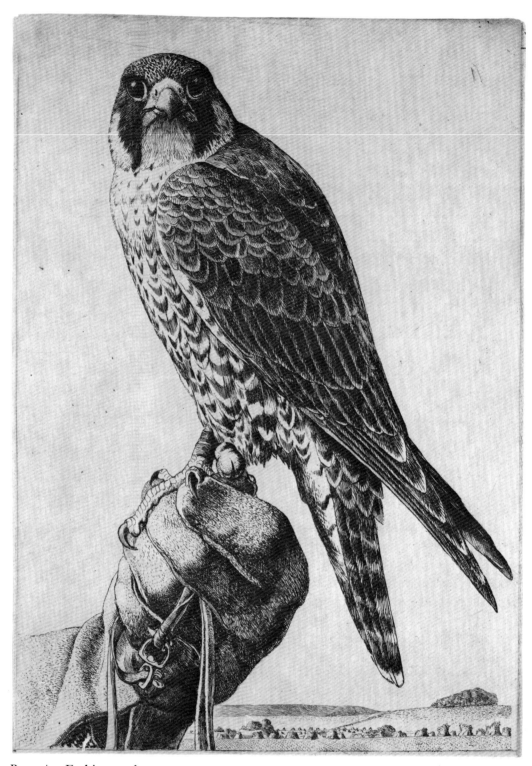

Peregrine. Etching, early 1930s.

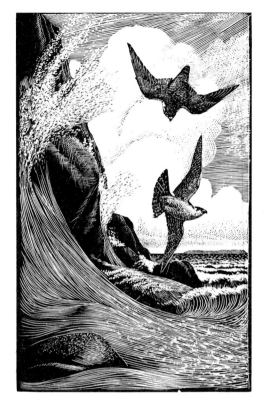
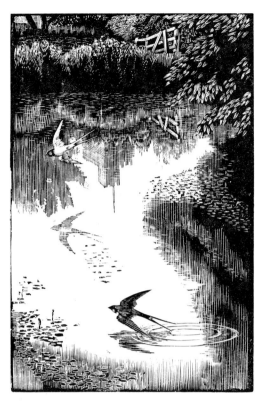

Falcons at play. Swallows over the pool.

He came of a line of people who knew a spade for what it was. He had no illusions about people. The butcher he had once drawn hadn't apologised for the smell of blood or mutton fat, and the hunting fraternity were happily engaged on something more ancient than fox-hunting and a royal sport, as old as anything done by Norman kings on the chase. Williamson, for all his sympathy with his otter hero, ran with Deadlock, Captain, Harker and the rest, to bring Tarquol to bay.

Charles made twenty-four full page engravings for *Tarka* and a set of tailpieces for the chapters. The engravings were without the slightest suggestion of romanticism and to a degree helped to bring the anthropomorphism of Williamson into perspective. The general effect of the illustrations was to darken the book and give it a nocturnal flavour which was exactly right. The hunting scenes were lighter because the otter is hunted by day, and these scenes have that suggestion of violence which is inseparable from anything to do with hunting, even when a quarry is not in sight. Tarka crossing the Burrows, the sand dunes at night, moves in Tunnicliffe's imagination, and even Williamson thought it perfect. He was (as he wrote to Charles) a little anxious about the expression on the face of a hound. He was slightly sentimental about the game little terrier who, locked to the otter's rump, and having resisted the huntsman's efforts to drag otter and terrier apart, was finally taken off under water, forced by near drowning to let go, and swam back again to the shore. The sketch was

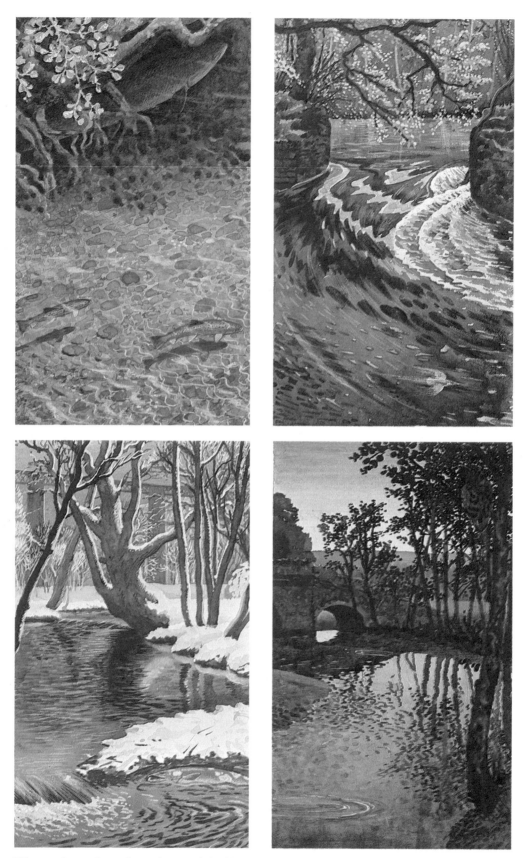

Watercolour plates from the special edition of *Salar the Salmon*, 1936.

precisely apt and *suggested*, he told Tunnicliffe, the terrier returning full of fight. Whereas Tunnicliffe might have put in someone lifting him up and striking him and this would have been 'overmuch'.

Later on in the same letter Williamson made one of his many attempts to discredit his publisher, advising Tunnicliffe not to take instructions from Constant Huntingdon. If he had followed Huntingdon's advice, Williamson claimed, all the 'cosmic stuff' in the winter chapter would have been cut out. Indeed someone like 'C.H.' had cut out 1,000 words or so from the French edition. There were endless comments in this, and many other letters Williamson sent Tunnicliffe concerning his interpretation of Williamson's words. It was natural that, the relationship having developed on the basis it had, Williamson was more and more encouraged to insist on Tunnicliffe seeing what he himself had seen. Williamson really wanted Tunnicliffe to accept his fantasy. Charles did all he could to oblige but it did not help to be told that Tarka was a figure of destiny. For atmosphere appropriate to his fantasy Williamson recommended Charles to read Heine's poetry. This was what he must strive for!

Before inviting Charles to Devon Williamson had already mentioned other early works of his which might be illustrated once he had rearranged and edited them. He told Tunnicliffe in a letter that he had recovered rights from his former publishers and had now rearranged and 'regraded' the stories. The work of illustrating would naturally fall on Tunnicliffe and these works would make the Cheshire artist generally known. Williamson was hoping to retrieve rights in two other books to add to the ones he had now recovered, but despite this blandishment Tunnicliffe must not look for too much in the way of money. Williamson expected the illustrated *Tarka* to sell 5,000 straight away, although the others would not. *The Lone Swallows* and *The Peregrine's Saga* had only sold 300 in two years when first published. Now the fame of *Tarka* would carry these early works into the limelight and Tunnicliffe with them. Thus the books and the artist would come into their own! It was, to be sure, a hopeful dream. Tunnicliffe could not expect a penny more than the small fee Putnam paid him, but Williamson himself would greatly benefit if the plan succeeded. The signs were favourable, Williamson said. He didn't need to tell Tunnicliffe that all he would get was the praise of critics. The money, if it came, would go into Williamson's pocket.

Tunnicliffe was in due course commissioned to do *The Lone Swallows* 'and other essays of boyhood and youth' which Williamson had written before 1921, and *The Peregrine Saga* 'and other wild tales' which he had written in Devon and London in the years 1921 and '22. *The Old Stag* 'and other hunting stories' had been compiled between 1921 and '24. Putnams lost no time in getting these illustrated editions on the market. Letters between Devon and Macclesfield arrived like a spring migration of birds. It was an unusual day when only one rambling epistle came. Williamson encouraged Tunnicliffe to do sketches for a story, *The Backbreaker's Bride*, which he had sold to *The Windsor Magazine*, pointing out what a very good thing for Charles the combination would be in the future – if he had the sense to stick to Williamson alone and not 'go whoring' after strange, 'feet of clay' gods. Williamson warned Charles not to form too high an opinion of himself or he would come down, at forty, to being a 'Chelsea groucher', saying he had never been appreciated. Williamson's introspection waxed for a brief moment or two. He confessed that he himself suffered because he had had

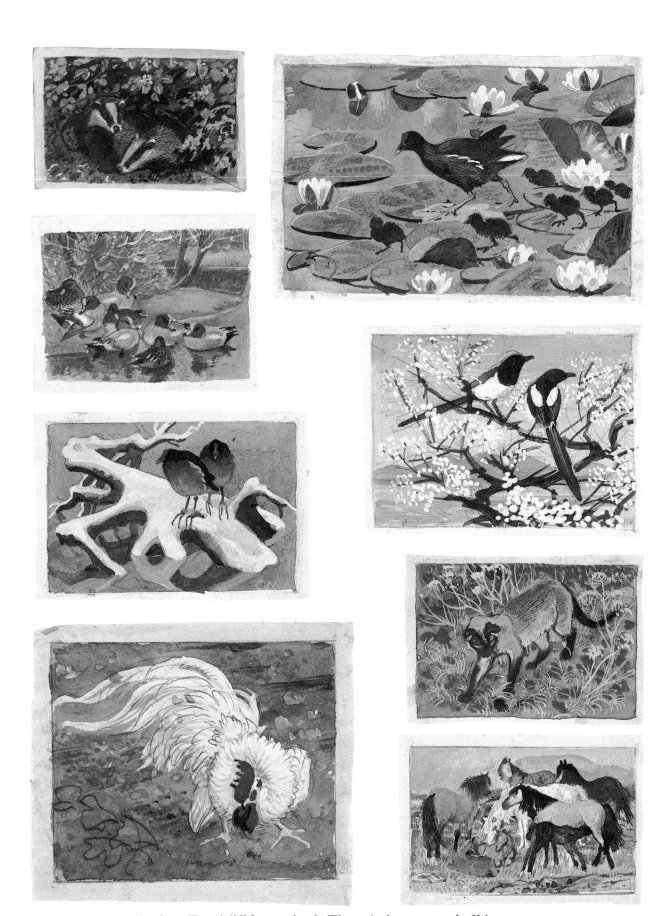

Composition studies from Tunnicliffe's scrapbook. The artist kept a record of his paintings with these tiny watercolour sketches.

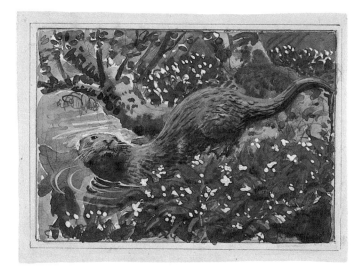
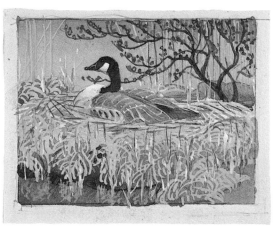
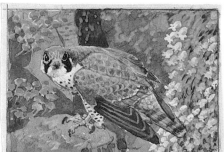
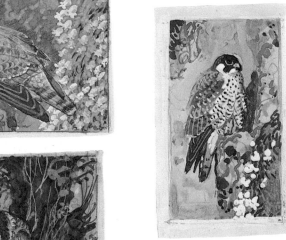
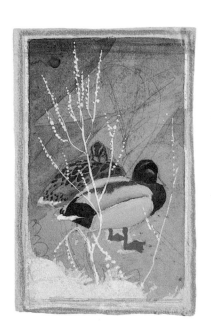
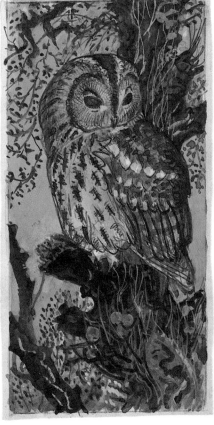
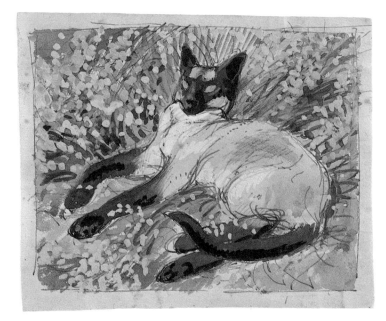

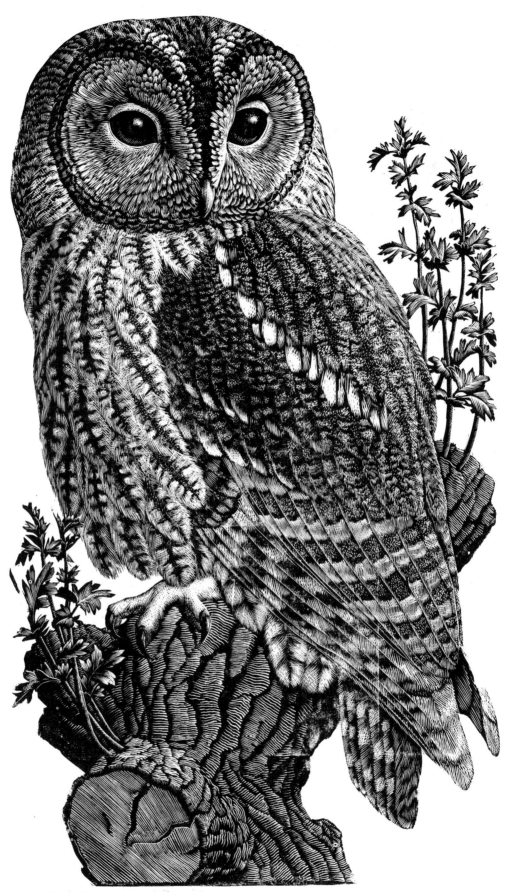

Wood Owl. Wood-engraving, 1946.

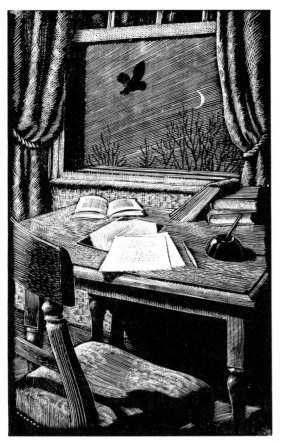

The writing-table. Goldfinches and appleblossom.

too big an idea of his worth, confusing artistic value with commercial demand. Now he had to start again. If he hadn't been so fastidious, he said, he would have been getting £400 for a short story, instead of being thrown out 'by all' for the past five years due to his own silly conceit. He regarded Tunnicliffe as more balanced than himself had ever been, and knew he would get on steadily, his 'house built on rock'.

Williamson's own domestic situation was about as unstable as possible. He was involved in the calf love of a young girl over whom he had apparently lost his head. He burdened the Tunnicliffes with his torment over what the girl really felt, how her parents reacted, what would come of it all in the end. The burden was something the Tunnicliffes hadn't bargained for. Williamson wrote rather confused letters, jumping from one subject to another, telling them that his food went sour in his mouth, his head ached. He thought of killing himself. On another occasion he revealed how he had suffered from the domination of others ever since childhood, from his father, his schoolmaster, editors, etc., all trying to mould him into their own images. All this had been mental torture which had come to a head in 1914–18, but still went on. But he then switched to the matter of illustration, saying that a hound Tunnicliffe

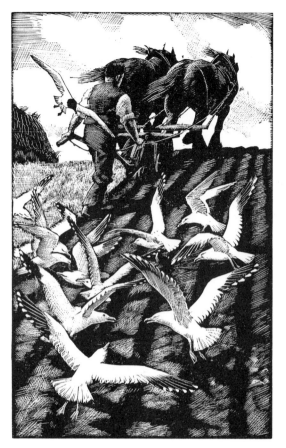

Following the plough.

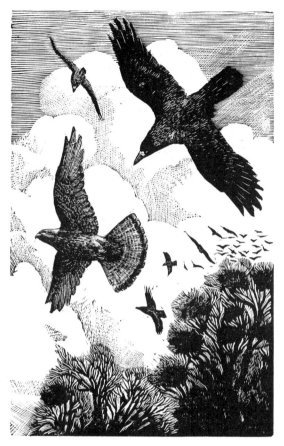

Rooks mobbing a kestrel.

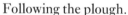

had drawn would have to come out because it was a bit too dramatic. That was the criticism he had had from hunting folk – he didn't know about 'people in ABC bunshops or Putnams!' In future he would stand no nonsense at all nor countenance 'parasites creeping in'. Tunnicliffe concerned himself over the hound and did what the rational Williamson demanded, ignoring the baffling matter with which the essential message was overlaid. Williamson was not an ordinary man. From the very start his oddness had been something Tunnicliffe had had to accept and he went on accepting it. At this particular moment he was finishing the *Tarka* work and preparing to go down to Devon to see the stag hunted. Before he left for Devon a letter from Williamson's secretary told him that Williamson thought the work magnificent – 'in other words, just right'. There was a P.S. to the letter which told Tunnicliffe that Williamson had vetoed a bit about eels swallowing their mates, and had cut out a bit about the gassing of otters. Williamson was concerned not to blemish the image of otter-hunters and give ammunition to those who opposed hunting.

The Lone Swallows was right up Charles's street. He did some excellent engravings of boys bird-nesting, a farmer leading a horse, some eager 'sportsmen' on a London rubbish dump

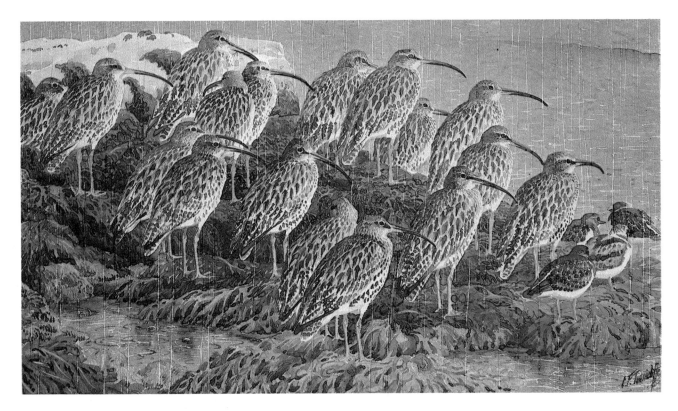

Curlew in the Rain. Watercolour. Exhibited at the R.A. in 1966.

and of course, the swallows, which gave the book its title. A second stay in Devon was necessary for *The Old Stag* and then for *The Peregrine's Saga* he went down to Avebury in Wiltshire to acquaint himself with the business of falconry and the precise details of hawk harness and hawk management:

I followed the young falconers into the paddock behind the inn . . . In the shade of the lime trees was a line of perching birds, some of which greeted the return of the young falconers with shrill calls. Absorbedly I watched the unhooding of the falcons: with a deft pull of teeth and fingers the hoods were slackened and slipped off the birds' heads to reveal pairs of wonderful dark eyes, which gazed round haughtily . . . All these peregrine falcons were young birds which, only a few weeks before, had been nestlings in cliff-side eyries. They were beautiful in their first plumage of grey, brown-laced backs, dark crowns, and striped breasts. I made many studies of them, but this meet of falconers had brought other birds to the paddock. At the end of the line was a fine adult goshawk, a bird greater in size and fierceness than any peregrine. It sat upright and still, its cruel yellow feet grasping the leather padding of the bow-perch. But the feet were not so cruel as the yellow-ringed eyes,

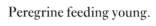
Peregrine feeding young.

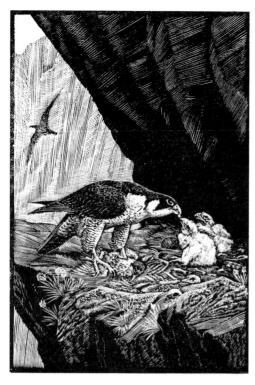

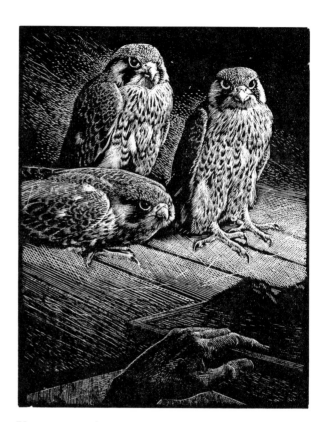
Young peregrines.

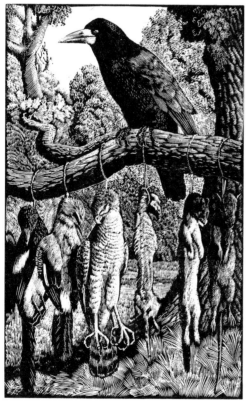
The rogues' gallery.

which glared at every moving thing, and did not miss the smallest bird which passed over. I was fascinated by this hawk and could not resist the chance to draw it. A front view of the bird's head was one of the most devilish things I had ever beheld. But, in spite of this, it was beautiful, and irresistible, and stole some of the time which had been intended for the drawing of peregrines . . . *My Country Book*

The Peregrine's Saga was published in the illustrated edition in 1934. By this time Williamson was dividing his energies between *Salar the Salmon* and his novel which he referred to as 'S.B.'. *The Star Born* was his wildest flight of fantasy. It was going to be something special and Williamson kept it under wraps in his correspondence. He was inclined to take the same attitude with things relating to *Salar the Salmon*. Perhaps he thought someone might steal his best ideas. No one but Williamson could have written *The Star Born*, but it had little chance of becoming a bestseller. When Tunnicliffe had to read it, and interpret what Williamson was trying to say, he was completely baffled. Only Williamson knew, for it had come from the deepest recess of his troubled mind and would perhaps have taken its author another book to explain. The pressure to get the work done in time was as much as Tunnicliffe could bear. When the time came for the publication of *Salar* – it was written at Shallowford in the early months of 1935 – Tunnicliffe, who had provided both colour and scraperboard illustration, had taken about all he could from Williamson. The change in their relationship was indicated by Williamson ceasing to sign his letters 'Bill' and reverting to 'H.W.' He wrote to 'Dear Tunnicliffe' and ceased to address him as 'Dear Tunny' but he told him that he had great plans to have *Salar* in very special de luxe editions with a few copies with hand-coloured engravings. He might also have copper engravings. He didn't say who would pay, or how much the overworked Tunnicliffe might expect for the handwork, but he repeated that Tunnicliffe would do much better in the long run by keeping exclusively to his work.

They finally quarrelled and parted over the adipose fin of a salmon, but it could have been over almost anything at this time. Williamson wrote to say that his magnifying glass revealed something he had not spotted before – that the adipose, or pennant fin as drawn in one of Tunnicliffe's *Salar* illustrations, was wrong. It was too large and the shape was a back-fin shape, not like a bit of celluloid stuck on. Williamson followed this critical comment with a description of his great scheme to start a new life and get away from the gossips of North Devon. He was hoping to move to another part of England to begin again as a farmer. He would have a small mixed farm and if he managed to pay his expenses and get his butter and eggs free he would not be doing so badly. It was only a dream at the moment but something he must bring about or perish of 'unnatural living and exhaustion'. He felt that writing with a life of exercise and interest would become easy and good. *Tarka*, he feared, was dead in America after only 2,000 copies, and not one sold in three years, so let it be farming and plenty of good honest muck! He had, in fact, once written to Tunnicliffe patronisingly saying he preferred farmers, however 'slow-witted and greedy for money'. He could take no more of high-souled people. Tunnicliffe himself couldn't take that magnifying glass on his salmon

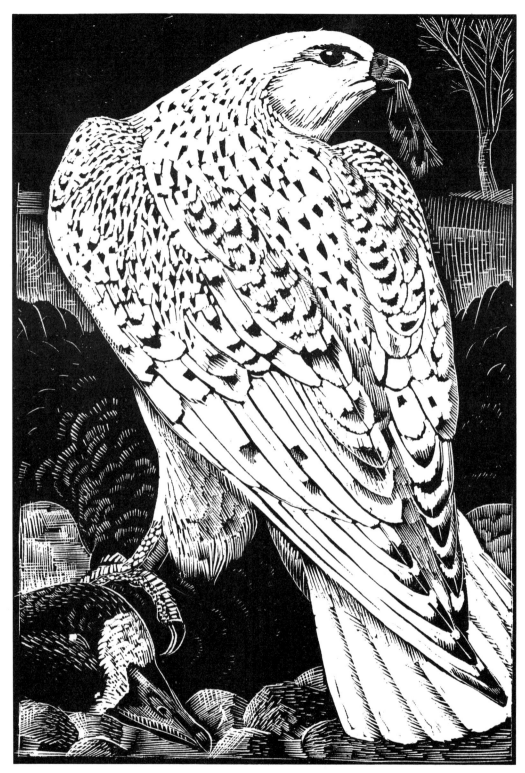

Greenland falcon with wildfowl.

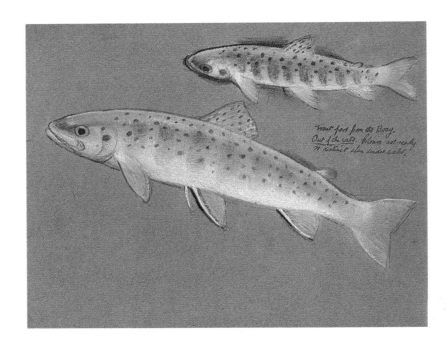

Brown Trout. Field sketch from the River Dane, Cheshire.

Portrait sketch of an otter. Chalk with watercolour.

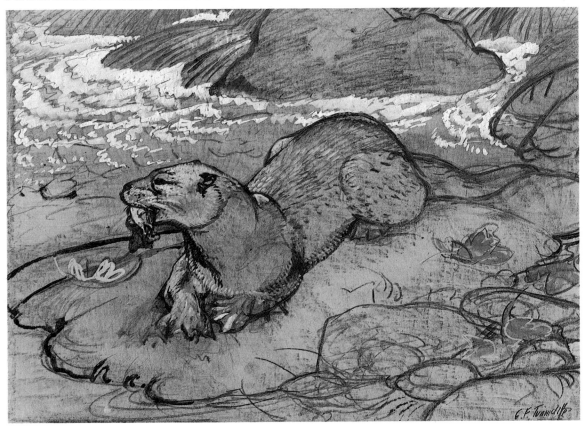

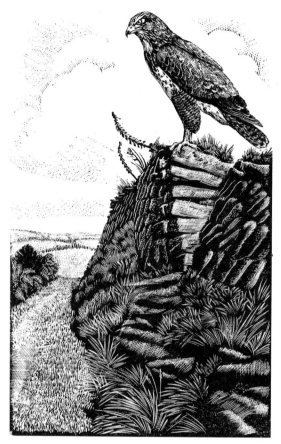

Buzzard watching for prey.

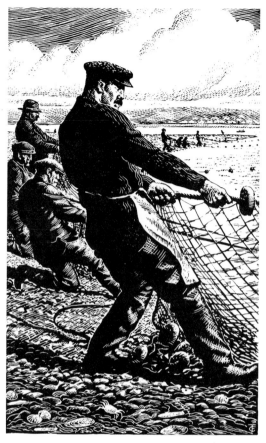

Hauling the salmon net. Frontispiece
scraperboard from *Salar the Salmon*.

nor, to get to the root of his discontent, that he was being forced to put so much into Williamson's work for so little return. He wrote to Williamson and told him exactly what he thought of his criticism and his publisher. Tunnicliffe was roused. There was a limit, and Williamson hadn't seen Tunnicliffe's etching of *The Bull*, perhaps, or if he had, he hadn't realised that the Cheshire man had blood in his eye. On receiving this blast from Macclesfield, Williamson had double-checked and climbed off the pedestal. To avoid a second barrel from Tunnicliffe he wrote to Winifred confessing his own observation was at fault. He had, in spite of the magnifying glass, made a mistake. After a week of re-writing a book for someone his sight was 'incompetent'. He was 'put down' to think that Tunnicliffe had sent him a blank communication without any 'Dear Bill' or 'Dear B.' The artist must bitterly regret his association with him through *Tarka* so to decapitate him. One was no good without a head, but was his letter really insulting? He hoped that Tunnicliffe might modify this view in time.

Salar the Salmon was nothing like as successful as *Tarka the Otter*, although the watercolour illustrations for Faber's edition were delicate and quite exquisite. Williamson

didn't write to say what he thought of the final result. He went off to America to write a series of articles for *The Sunday Referee*, and eventually came back to set up as a farmer in Norfolk. Many people will agree that *A Norfolk Farm* was as good as anything Williamson ever wrote. Tunnicliffe would have been the artist to illustrate the story of Williamson's struggle to come to terms with life there. There could hardly have been a quarrel over the shape of a Suffolk Punch or a Percheron, a goose or a Norfolk turkey. Tunnicliffe did the end-paper maps. Williamson lived in Norfolk for some time until he decided that Devon was bearable once again. He returned there to pursue his writing career and try to make his mark as a novelist, which he never did. For Tunnicliffe the lesson was plain. He must never again allow himself to become involved in the affairs of an author whose work he had to illustrate.

Aftermath

It has been necessary to amend the foregoing account of Tunnicliffe's transactions with Williamson, for although he read and approved what was written here, Charles seems to have overlooked the fact that he had had some correspondence with Williamson thirty years after publication of *A Norfolk Farm*. In 1963 when Tunnicliffe was asked to do some drawings for a paperback of *Tarka the Otter* he evidently asked Williamson what he thought of these drawings. Perhaps the paperback publishers insisted on the drawings being shown to Williamson, but it was only after Charles Tunnicliffe's death I came by further letters. All of his work, and the files in his studio, were left to his sister, Dorothy. She asked me to put the Williamson letters in some sort of order and handed me several letters with a Norfolk postmark, and one with an Ilfracombe postmark, which for some reason had not been included with the others I had already handled. There are now more than sixty letters in this collection and more than a dozen postcards. Those with the Norfolk postmark were written in 1940 and were largely about Williamson's life in the Stiffkey district where *A Norfolk Farm* was situated. One referred to the end-paper maps Williamson had asked for. He didn't want this map to be 'too accurate' or define things so well that people would know where he was. He said he preferred to fictionalise such things. This, and subsequent letters to which Tunnicliffe probably replied without much enthusiasm, served to help Williamson to get things straight in his mind, for he again talked of his domestic problems and his marriage. He said he had earned only £300 the previous year, and only £16 in the past twelve months, from writing. He was £1,200 in debt, with no prospect of being able to pay. The colour illustrated edition of *Salar* (there had, of course, been a black-and-white edition) had for some reason not taken on. It had sold only 140 copies all told. The book was selling (the black-and-white edition, presumably) 200 copies a year at five shillings each. Williamson felt himself 'extinct'. (When they corresponded again it was in 1963. Williamson talked almost entirely of his marital troubles. There had been a time when his wife was seeking a divorce on the grounds of cruelty. Now that was all over. He felt that 'one's fate is one's character' and at sixty-seven he was 'a bit scared' or dulled, at the prospect of getting older and older and a bore.) From what I know of Tunnicliffe I doubt whether he gave Williamson a chance to impose on himself and his wife again, although Williamson seemed to need a father confessor.

— 5 —

Changing Backgrounds

THERE WAS NO dilemma for Tunnicliffe in considering whether he should concentrate on his own ideas of art, and do exactly what he felt he should do, or take what the commercial world had to offer. He could do nothing else but seek a commercial outlet or find employment as a full-time teacher of art. His training had equipped him to teach and he had the necessary qualifications. Art in capitals was part of romance so far as the young Cheshire man was concerned. He knew what he could do, and he knew what he had to do. Some fine etchings, produced to supplement his income, had made his stay in London bearable. *The Bull, The Cheshire Plain, The Thatcher, The Winter Landscape* had not only sold, but earned him some small recognition. Back at Macclesfield, even when he was hopefully working for Williamson and mindful that he was making a name as a wood-engraver, he couldn't afford to neglect the commercial outlet. Aspiring to the Academy, which had accepted his first offering in 1928, he knew he must sell what he could where he could. His greatest strength lay in the background he had, and upon which he could draw whenever the opportunity presented itself. It was undoubtedly true that where advertising companies called for the agricultural scene, and a great many did, even though their produce had no relevance to it, nine out of ten commercial artists lacked the intimate knowledge of the scene and the animals and implements.

But Macclesfield was no budding artist's dream of a north-lit studio in peace and seclusion. It was, in fact, rather grim and uninspiring. Neither Charles nor Winifred had illusions about art. Winifred taught her subject. Tunnicliffe worked in the shed that was his studio, his head down, pencil, pen and ink and colourwash in his hand. With his father's death Tunnicliffe felt that the background to his formative years had irretrievably gone when his mother gave up the farm and moved into the house he had bought for her in Macclesfield. For some time, when he managed to get out, he sketched and painted the Cheshire landscape, the canal, the wharf, the longboats, the fields and distant hills and little hamlets. He had never really been interested in landscape, but the content of it. His more common encounters after Lane Ends were the birds of the Cheshire mere and the moss, hence the sketchbooks and field notes, but where he would go from here Tunnicliffe hardly knew. He was much too busy with

A winter sketch of Birtles Pool near Macclesfield, c.1946.

commercial commissions really to think where he was going. He could never have gone in for portraiture, not because he lacked ability in the department of drawing from life, or the vital knowledge of anatomy, but because he was basically a realist. Few successful portrait painters dare present the truth. In *My Country Book* Charles perhaps unwittingly revealed why he would never be a portrait artist:

> The parishioners of my native village were organising a garden fete, and someone suggested a way in which I might help in raising money. I agreed, on condition that at least forty of the parishioners sat for pencil portraits, the drawings to remain my property. In return I would exhibit the drawings at the fete and the parish would have whatever money was raised as admission to the exhibition. Round the countryside I went, drawing churchwardens, choirmen, farmers, members of the Mothers' Union and Girls' Friendly Society, the village blacksmith and the lads of the village, and a 'fine time was had by all' but especially the artist! One farmer's wife threatened to tear down the whole exhibition if I exhibited the drawing I had made of her husband. Another lady of the parish thought I

[79]

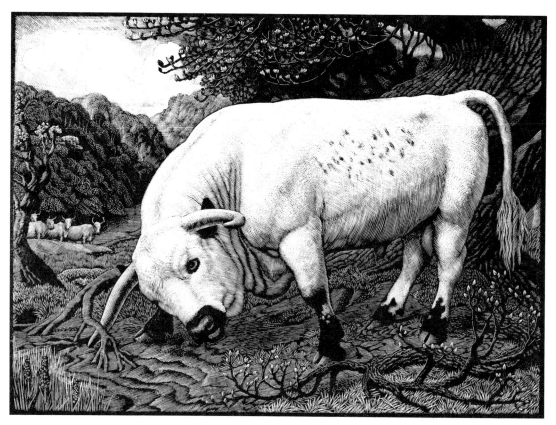

The Chartley Bull. Wood-engraving, 1939.

was no artist as I had drawn *all* of her chins; yet another, who was not quite clear as to why I was doing the drawings, posed for me in her curling pins, and was frantic when she heard the news that she was to be exhibited locally. One farmer who had promised to sit for me must suddenly have changed his mind, for when I arrived in the farmyard all ready to draw him, he almost foamed at the mouth and threatened to shoot me with his twelve-bore. I beat a hasty retreat from the farm precincts and subsequent events showed that I had been wise in doing so. The exhibition was eventually held without mishap and I greatly prize those drawings for they are a very intimate link with my boyhood.

The pencil drawings, still preserved among Tunnicliffe's early work, are a remarkable collection of peasant portraits, faces that Pieter Breughel himself might have chosen for *The Feast*.

The long commercial stint upon which Tunnicliffe set out on his return from London was initially promoted through contact with a student from the R.C.A. with whom Tunnicliffe got in touch, knowing that his former colleague had gone into the advertising business. It was one of those fortunate outlets an aspiring artist hopes for when he needs to make a living. Tunnicliffe made the best of it, learning the technique of drawing for commercial reproduc-

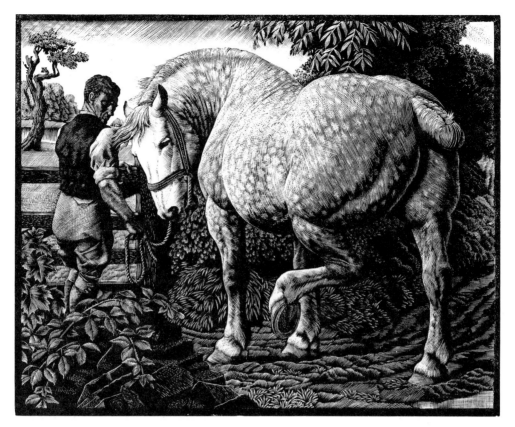

The Percheron. Wood–engraving, 1940.

Cat and Kittens. Wood–engraving, 1936.

Redwings. Watercolour.

tion as he went along. This work involves craftsmanship beyond the mixing of paint or the cultivation of a talent for detail. Filling-in is the bugbear of the engraver and the scraper-board artist. Detail that is too fine becomes totally lost in the process of reproduction and when work is reduced the problem of preserving clarity becomes greater. What Tunnicliffe had above all was a determination to succeed at whatever he took on. He had the undoubted talent of being able to illustrate what he knew about – and what the customer asked for. His attention to detail, and his ability to take pains and master the commercial techniques, brought him all the work he could cope with. It became a problem to do it all. Winifred gave what help she could, but she was teaching full-time. As time went on and war became imminent it was obvious that there would have to be some adjustments. When the war finally turned everyone's world upside down Tunnicliffe found himself back at school, teaching at Manchester Grammar School. As a full-time art master he had a turnover of 1,400 boys through his class once every fortnight. It was very different from his part-time stint in London, and a thousand miles away from either Macclesfield School of Art or the Royal College. Design and poster work were no more inspiring for the class than they were for the master who was aware that art, probably more than any other subject, really depends upon an obsession. Art is something that can be cultivated, if it is there, but little impression can be made upon reluctant pupils. Most of those 1,400 pupils had little talent and those who had could hardly be improved by brief contact with even the most competent of instructors. Tunnicliffe did what he could do for those who were taking art for School Certificate, and hurried home at the end of the day to get to his drawing-board. There was always work to be done. He would work until past eleven o'clock and hurry to put his work on the train to London before going to bed. Winifred's part was considerable for she would not only have his evening meal ready but his 'implements', his pens, inks, paper and so on, laid out by his drawing-board so that he would waste as little time as possible in getting to work. So it was that illustrations needed for the wartime 'Dig for Victory' campaign and other Ministry of Food promotions got into the newspapers and magazines for which Tunnicliffe worked, albeit indirectly through one of the big advertising organisations. Between times Tunnicliffe was mindful of the need to exhibit his work, when he could, at Manchester Academy and the R.A. It was at Manchester that he met L. S. Lowry.

Lowry and Tunnicliffe were both destined to become members of the Royal Academy in due course, one as a painter and the other as an engraver. Until this time Tunnicliffe had devoted himself in the main to the animals of the farm. As his father had done, he stuck to his last, but cultivated the subjects of his more recent background, the birds of places like Goldsitch Moss and the meres of the Cheshire plain. Lowry was interested in people against the dwarfing background of industrial buildings and grim streets dominated by factory chimneys. His world teemed with little people, men, women and children, whose articulation was suggested by a few deft strokes of his brush, so that a boy might seem poised to step off a pavement or a dog about to cock its leg. All this was a far cry from the bull enraged, the stallion and the groom, that winter scene in rural Cheshire, or even those corners of Tunnicliffe's 'Silk Town' depicted in watercolour. Humanity in the mass that pleased Tunnicliffe was likely to be Breughel's scene in which faces and features were recognisable.

Lily-beds at Redesmere (*Mereside Chronicle*).

Gawsworth Old Hall Pool and Church (*Mereside Chronicle*).

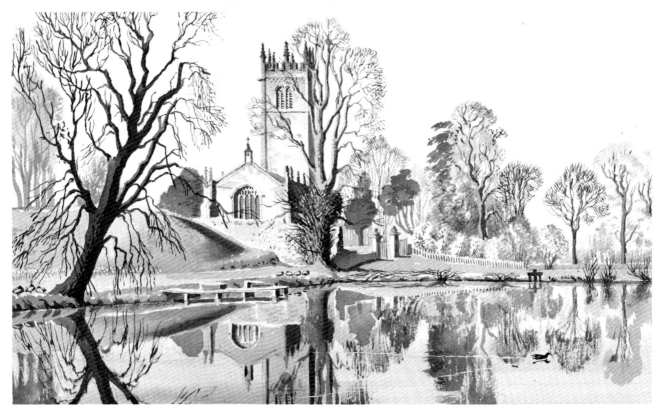

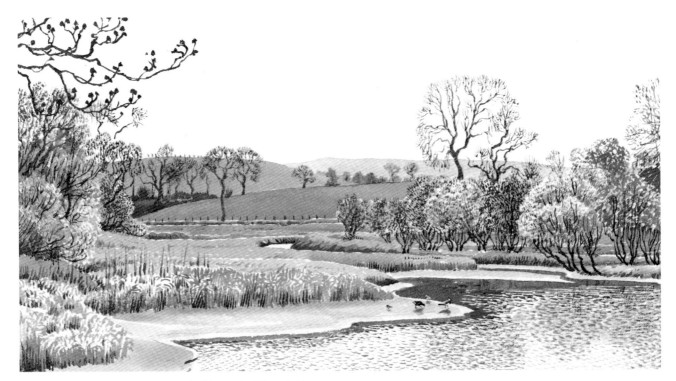

Siddington Pool from the road (*Mereside Chronicle*).

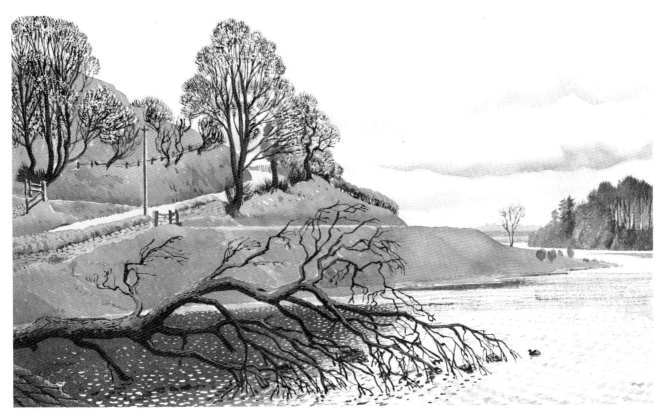

Fallen Ash Corner, Bosley Reservoir (*Mereside Chronicle*).

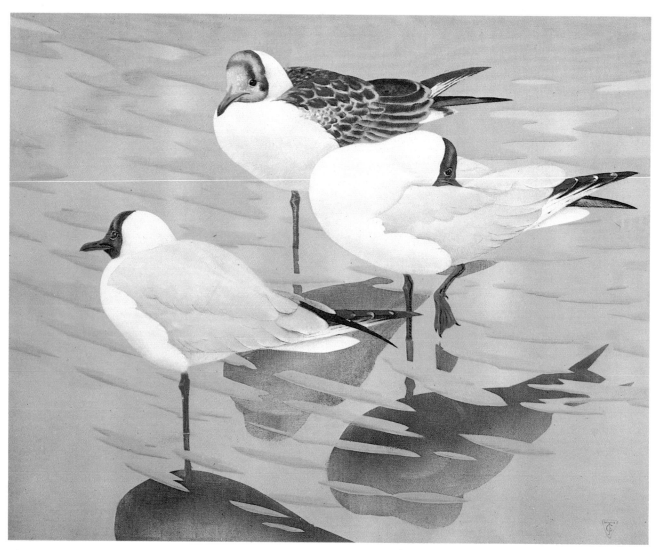

July Gulls. Oil on unprimed cloth (1938).

At this time Lowry was a long way from being generally acknowledged. There could hardly be two artists with more opposed standpoints from which to depict the living scene.

By the time the war ended Tunnicliffe had been made an A.R.A. as an engraver. This happened in 1944, sixteen years after his first acceptance. He had already been accepted as a Fellow of the Royal Society of Painters and Etchers. Recognition by the Academy implies that an artist's work is outstanding enough to have been selected on a number of occasions. Tunnicliffe had done an engraving of a Shire horse that measured $11'' \times 9''$, a most exacting, large piece of engraving by any standard. He afterwards found himself corresponding with Sir Alfred Munnings about this particular offering, for Alfred Munnings not only recognised a fine engraving, he knew a man who knew horses, even if he himself was mainly concerned with blood horses or finer-bred horseflesh. Elevation to full membership of the Academy came when Winifred and her husband had uprooted themselves from Macclesfield and

settled in Anglesey – ten years after Tunnicliffe was made an A.R.A., the minimum time usually prescribed for graduation from A.R.A. to R.A.

While he was so busily engaged with schoolmastering, commercial work and work for the Academy, Tunnicliffe somehow found time to produce a number of books of his own, beginning with *My Country Book*, published in 1942. Largely the story of his own boyhood and youth, this little book of less than a hundred pages is, as one might expect, lavishly illustrated in monochrome and colour. Lane Ends Farm is there in colour and monochrome. Even the lesser drawings are as impressive as the large ones. We see the farm and the hills beyond, St James's Church and one of those pencil portraits of John Bullock, 'farmer and good neighbour'. Could he really have been called John Bullock? Indeed he was. And there too, is the Shire stallion, the village, and the farm, 'from Judy's Lane', as well as 'Fowls roosting in a damson tree', a really beautiful drawing of bantams at roost among the damson blossom. This drawing was the inspiration for a later oil painting, one of more than two dozen which Tunnicliffe exhibited while he was living in Macclesfield. *My Country Book* is a most nostalgic little work produced before the artist was really old enough to know this feeling, if he ever did. Some of the drawings have an association with other work Tunnicliffe was engaged upon, for a 'Williamson' salmon leaps in a colour plate and otter hounds mark a

Goldsitch landscape, with short-eared owl and curlew. From *My Country Book* (1942).

Radnor Mere from the woods
(*Mereside Chronicle*).

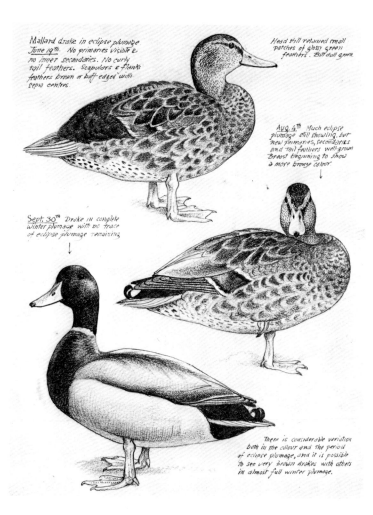

Mallard drake in eclipse plumage. Pencil and
ink studies from *Bird Portraiture*, 1945.

The island in the upper pool, Oulton Mere (*Mereside Chronicle*).

bank in one of the monochromes. At some time he was off to the border of Ayrshire and Galloway to draw salmon in the River Stinchar, and he drew Iona Cathedral with the Sound of Mull beyond. The London scene was less inspiring for he included only Fulham back-gardens, the life-class at the R.C.A., and a leopard at London Zoo.

Following *My Country Book*, in 1945 the Studio brought out *Bird Portraiture*. This was a little classic that greatly encouraged aspiring bird artists. Apart from the superb illustrations, it contains some revealing paragraphs about Charles's approach to his art, and his method of working. Here, for example, is the first mention of his 'bird maps', the measured drawings which occupied him to the end of his life:

> For some years, I have been in the habit of making careful measured drawings, in colour, of any dead bird which has come into my hands, providing it has been in fresh condition. Whenever possible I have drawn the birds exactly life size. I try to arrange them so that the upper surfaces, including that of the fully-opened wing, are shown: the under surfaces with wings in the same position: a side view with the wings closed, and any other details, such as a front view of the head, accurate studies of legs and feet, and drawings of single feathers, – in fact, anything which I think may be of use . . .

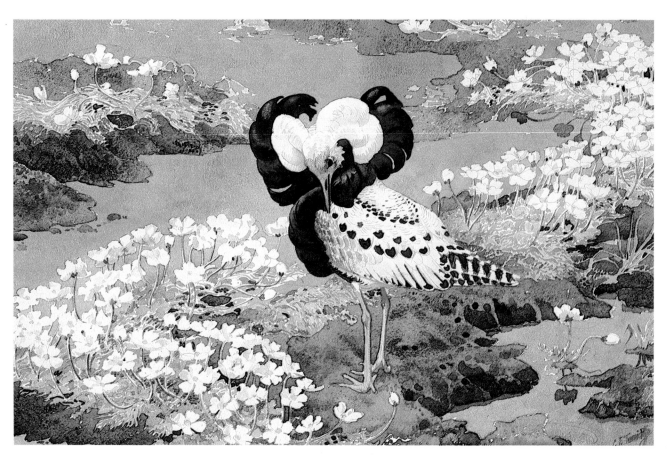

The Wanderer (a ruff). Watercolour. Exhibited at the R.A. in 1950.

Particularly significant, in connection with Charles's own pictures, are his remarks about settings:

It is in this matter of settings that so many bird pictures fail. Often the bird is painted skilfully, but its surroundings 'fizzle out' into a doubtful and uncertain hotch-potch of unstudied details which ruin the picture.

If you would see fine examples of bird-painting in which the settings have been given the same meticulous care as the birds themselves, you have but to study the work of the Chinese painters. Note the exquisite drawing of flower and branch, tussock, reed and bamboo, an exquisiteness which does not detract one jot from the importance of the bird, but which does give a precious and lovely quality to the work. You might also spare some time to look at the work of John James Audubon, who did such admirable work in drawing and painting the birds of America. His attitude towards birds was not purely an artistic one, as he was a fine ornithologist for his time. His work was scientific in intention. Nevertheless, it was also artistically excellent, a combination of qualities which is woefully lacking in many modern text-books on birds.

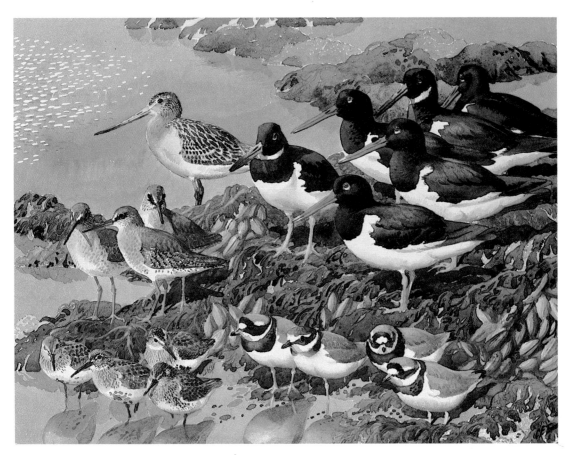

At Low Tide. Watercolour.

After publishing these delightful brief volumes, Charles became more ambitious. Four books followed which are today desperately sought by collectors and upon which his great reputation as a book illustrator largely rests. *Our Bird Book* (1947), written by Sidney Rogerson, gave Charles his first opportunity to use colour illustrations on a generous page. *Mereside Chronicle* (1948) was written and illustrated by the artist, as was *Shorelands Summer Diary* (1952). *Both Sides of the Road* (1949) was another collaboration between Tunnicliffe and Sidney Rogerson.

Mereside Chronicle – 'with a short interlude of lochs and lochans', is a delight for the bird-watcher and the ornithologist. It was written at that time when Tunnicliffe and his wife were finding life in Macclesfield as much as they could bear. "We couldn't wait to get away from the place," Tunnicliffe told me. "I felt that my material was anywhere but there. I had to get away to the meres and other places where I could find subjects. There was nothing at Hurdsfield that pleased us and we had been there too long!" The story of the meres, lochs and lochans is full of waterfowl, as one might expect, but among its numerous half-tones there is more landscape than hitherto found in any of his sketchbooks – Bosley Reservoir,

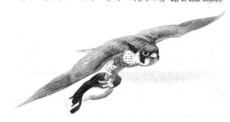

Tunnicliffe's rough paste-up for *Shorelands Summer Diary*, 1952, showing his proposed lay-out and page width.

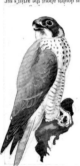

Gawsworth Hall, lily beds at Redesmere, the lochans of Rannoch Moor, cuckoos by Loch Glendhu, and back again to Siddington Pools and his native Cheshire. Altogether this book contains some of Tunnicliffe's best pictorial work as opposed to landscape serving as background to bird portraiture, but the quality of reproduction was a great disappointment to the artist.

Both Sides of the Road is the strongest link with the pastoral scene of his boyhood and youth on the farm. The text is Sidney Rogerson's. The images are those imprinted, long ago, on the mind of young Charley Tunnicliffe – the steam engine at the threshing, turning hay in the old-fashioned way with rakes, hand-shearing sheep in East Cheshire. There were twenty-three colour plates in *Both Sides of the Road* and sixty illustrations in black and white that set the scene perfectly. Whichever came first, the art or the text, the result couldn't have been better.

Shorelands Summer Diary is, as its title reveals, a different story, a different place, a different tune. It contains some of the best of Tunnicliffe's bird art. Every artist whose work is used for book illustration is likely to quibble about the reproduction, how the paper made his finest lines fill in. Collins did their artist proud. The colour reproduction of shoveller drakes, sheldrakes fighting, the red-necked phalarope, and ruffs wading in the pool, was all that their author could have asked for. Shorelands was the name of the house which the Tunnicliffes bought when they finally decided to move from Cheshire to Anglesey, finding

Shorelands. A pen and ink study from about 1950.

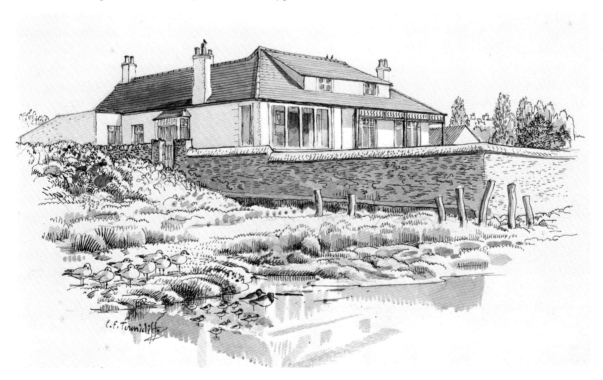

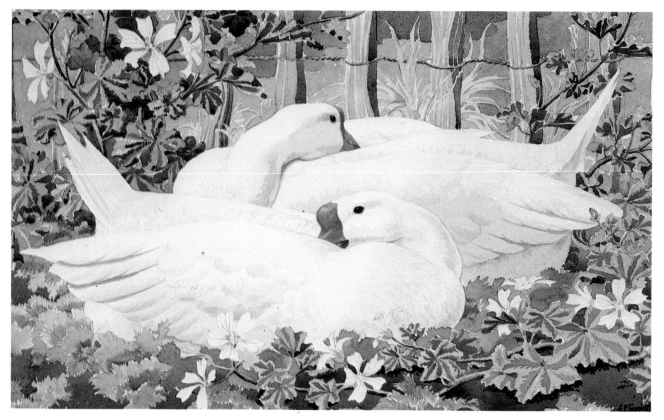

Geese and Mallow. Exhibited at the R.A. in 1944.

the scene they had dreamed of finding, a place where Tunnicliffe could do the kind of work he would later be commissioned to do by an increasing number of people to whom his work became known.

In the meantime, before leaving Macclesfield, Tunnicliffe had been considering oil painting, but oil with a difference. He had no great liking for the shine on finished oil that results from treating the painting after the paint has dried. He sought to produce a matt-finish oil painting. It may have been Winifred who suggested the use of dress material rather than canvas. She was, after all, concerned with craft and the use of materials. Winifred found the dress materials, generally of a brown shade, which Tunnicliffe proceeded to use in place of a canvas, stretching it for the purpose, as he would have done when setting out to use canvas in the conventional way. His sketchbook references provided subjects for larger drawings, which, scaled to suit his stretched dress material on its frame, he cut to make stencils, then carefully 'pieced' so that they could be used on the fabric. These paintings on cloth, assembled for exhibition in 1938, were quite unlike anything else Tunnicliffe ever did. They were oil stencils with a matt finish giving a very special, delicate texture. The subjects were his favourites – those handsome bantams in the damson tree, the white turkey, the hare, a farmyard gander, a barn owl, a blackheaded gull, a great crested grebe, and many others. The exhibition in a London Gallery of this set of paintings was not successful. In fact, not one painting was sold, but this can happen to an artist who experiments and produces

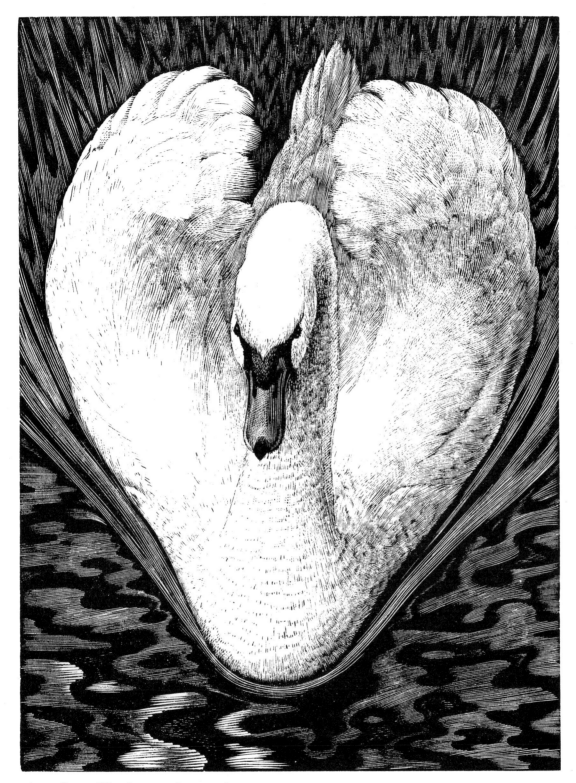

Angry Swan. Wood-engraving, 1936.

Thrush in Snow. Etching, about 1935.

Brown Trout. Etching, early 1930s.

something new and unusual. It happened to Tunnicliffe with a vengeance despite the fact that his birds were already being recognised and admired almost everywhere. His submissions to the Academy, after his admission as an engraver, were invariably in bird portraiture, albeit in watercolour and not oil, either on canvas or dress material. It was not long, however, before the 'fabric' oils were 'rediscovered' and sold. Tunnicliffe retained a few of his favourites – the hare, the only animal subject he recalled doing in this medium, the magnificent farmyard gander and the turkey cock. Some lucky buyer went off with the fowl in the damson tree, which was surely a masterpiece.

"I think," Tunnicliffe told me with some regret, "I might have done more with matt oil on fabric. It had possibilities which I might have cultivated. I did that set of pictures and did no more. When I look at the hare I wish I had carried on." I am sure that many people who collect his work, and come across a fowl in the damson tree or reproductions of this work, will wish that he had done more of them. Explaining how the stencil was made, a process which I have not been authorised to reveal, Tunnicliffe said, "Do you know, you are the only person I have ever told this to?"

I didn't ask if I might tell anyone else, nor would I have dreamt of asking. Fortunately I have forgotten the details of the process.

During the war the Tunnicliffes had sought refuge from Macclesfield, and Charles's commercial stints which involved long hours after his day at Manchester Grammar School, by going down to Anglesey for holidays. They stayed at Nant Bychan Farm at Moelfre, where they met 'Wack' Walker, striking up what was to become a life-long friendship. Wack had a wooden chalet in a field next to the farmhouse and was as interested in bird life as the Tunnicliffes were. Soon Charles was showing him his sketchbooks. They corresponded, when the Tunnicliffes went back home after their holiday in June 1945, about the plumage of a Montagu's harrier and Charles described how during their stay a friend had found him the nest of a nightjar, enabling him to make sketches of the sitting bird, despite a furious gale that made it difficult to keep the sketchbook steady. The letter also mentioned tree specimens gathered from Bodorgan and taken back to Macclesfield to be 'got down' on paper before they died. Wack had recommended the Cefni Estuary to the Tunnicliffes as a place where they would find species of birds different from those sketched at Moelfre. It was this that had taken them to Bodorgan and Malltraeth on the estuary. They were captivated by the beauty of the place and the wealth of bird life they found there. After putting up at The Joiners' Arms, to which they were warmly welcomed by the landlord, Bob Jones, the Tunnicliffes lost no time in acquainting themselves with the little place from which Charles could survey the peaks of Snowdon to the south and, a little to the south-west, the 'Rivals' on the Lleyn Peninsula. Charles decided that as soon as he could buy a house he would move there. Winifred was happy to make the move. She would give up schoolteaching and become a housewife. She had been brought up within sight of the sea. It was really part of her background.

Before they left The Joiners' Arms the Tunnicliffes, who had seen Shorelands, told Bob Jones that they would be grateful if, should the place come on the market, he would get in touch with them, and, as good as his word, Bob Jones shortly afterwards wrote to tell them

Cockatoo. Wood-engraving, 1938.

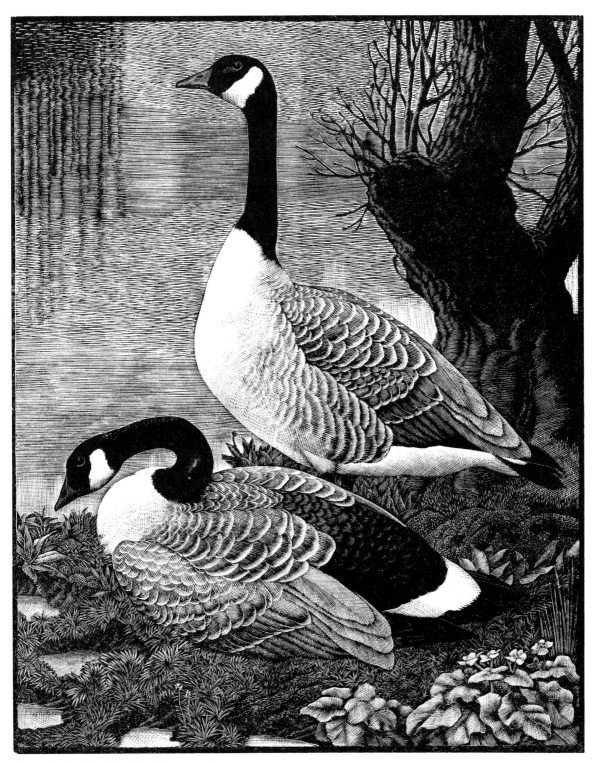

Canadas in Cheshire. Wood-engraving, 1939.

the house was for sale. The Tunnicliffes quickly stepped in and bought it. Their arrival at the house in March 1947 is best described by Charles himself:

On the evening of March the 27th, my wife and I crossed over Telford's great bridge which spans the Menai Straits, and entered the island county of Anglesey. We were no strangers to this fair country, but our journey to-day was different from all previous ones for, at the end of it, in a little grey village at the head of an estuary, there was an empty house which we hoped to call home as soon as we could get our belongings into it. Our other visits had been short holidays, spent chiefly in watching and drawing birds and landscape of which there was great variety. Several sketchbooks had been filled with studies of Anglesey and its birds, and we had been specially delighted to find that the island in spring and autumn was a calling place for many migratory birds, while summer and winter had their own particular and different species. Occasionally, to add to the excitement, a rarity would appear. Whatever the season there were always birds and this fact had greatly influenced us in our choice of a new home.

Our intention to establish ourselves in this Celtic land was not to be accomplished without opposition however, for Anglesey, the Mother of Wales, had built a little church on one side of our lane, and the stone wall of a cottage garden on the other. The furniture vans were monstrous and stuck fast between church and garden wall and could proceed no farther. After we had scratched our heads in perplexity, and listened to suggestions from interested observers, Môn Mam Cymru relented and sent a coal lorry to our aid. The sun shone, the furniture went into the house via the coal lorry, and the Shelducks on the sands laughed and cackled all day.

Shorelands Summer Diary

Shorelands was a paradise. Below his windows were all the wading birds Tunnicliffe could have wished for. A skein of grey geese flew down the estuary. On the gorse beyond the window there were stonechats and yellowhammers, more yellow, he felt, than Cheshire

Chinese Geese. Wood-engraving, 1937.

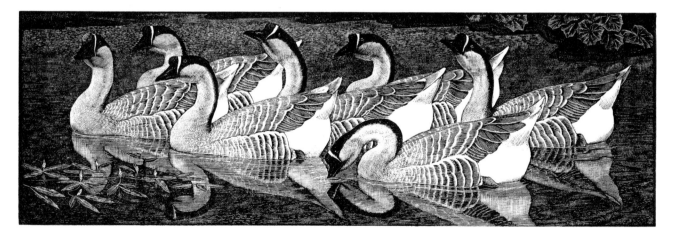

yellowhammers, and might this not be true, for food and climate make a great difference to the colour and conditions of most birds? Malltraeth and the marsh and sands harboured tens of thousands of birds. On his second day there he found great crested grebes on Cob Lake, a stone's throw from the house. A solitary pochard, copper-headed, swam with them and didn't bother to dive. *Shorelands Summer Diary* appropriately begins in April and runs to September of that first year, or it would have missed the breeding season of birds like the plover and the curlew, and many of the birds of the shore. What it doesn't do is tell of the pressure that was on Tunnicliffe to comply with all the obligations he had to meet deadlines and continue to supply what the commercial world demanded of him. He had new material, a very different background – whitewashed farms instead of red brick, old grey stone buildings, a kind of ancient architecture that went with farmland long ago dubbed the granary of Wales. Tunnicliffe's own farming background gave him a special understanding of the point of view of the Anglesey farmer. If he couldn't speak Welsh he could certainly speak the farmers' language when he looked at the beasts in their fields, admired their horses or their crops. The place he had chosen was wilder, had a bigger sky and a less wooded landscape than that of rural Cheshire, but he and Winifred were enchanted with their new home.

Shorelands Summer Diary advertised the presence of a bird artist on Anglesey. More and more people began to seek out the Tunnicliffes at Malltraeth, forgetting that a professional artist's life is no kind of casual dalliance with paint and pen. Many of the visitors wanted to talk about birds they had seen or about bird painting. Some wanted pictures. Tunnicliffe found himself accepting commissions to paint birds, not only for bird-watchers, but for sporting gentlemen who sometimes asked for hawks or falcons and occasionally animals such as the otter. It is hard for outsiders to realise that painting and drawing, however much the artist loves his work, are no easy occupations and that to produce work of a professional standard calls for enormous self-discipline. In a way the artist seeks to communicate what he sees to someone who looks at his work, but in order to do the work he must retreat and be alone, uninterrupted.

Tunnicliffe has been described as a reluctant painter, a shy, retiring man. There was a lot of truth in this. He loved his work, and settling in Anglesey was a deliberate step to get closer to a proper background, but it was also to withdraw to work in peace. The trouble is, as someone has said, the man who does fine work discovers that the world beats a path to his door – wherever he builds his house. Tunnicliffe was persuaded to write only one more book after *Shorelands Summer Diary*. Perhaps this was because the world had begun to come too often to his door.

~6~

Book Illustration

REMARKABLE THOUGH TUNNICLIFFE'S output had been as a watercolourist, etcher and commercial wood-engraver, as an illustrator of books his output can have been equalled by very few artists of the top rank. In a little over forty years he worked on eighty-eight books, illustrating for thirty-nine different authors or editors. In addition he produced six books of his own. Estimating that he did drawings for between eight and a dozen full pages for most of these books, not to mention the vignettes or chapter heads and tailpieces, and between 1940 and 1950 did no less than thirty-four books, one appreciates the demand such work must have made on his time. A letter he wrote to Norman Collins of Gollancz in June 1937 shows the sort of pressures he was used to:

June 7th 1937

Dear Mr Collins,

Many thanks for your letter. I shall be free to start the engravings for the bird book [*A Book of Birds*] at the end of this week. At a pinch I think I can probably manage between 70 and 80 engravings by August 25th but it is most difficult to estimate exactly. Some will take 2 days to cut, others half a day . . .

Six of the grand total of his books were, of course, for Henry Williamson where it really began. Three were for H. E. Bates and five for R. M. Lockley. Particularly generously illustrated with fine work were eighteen books of country essays by Alison Uttley and six for N. F. Ellison – 'Nomad' of BBC fame. The list, which appears at the end of the book, may be incomplete. Tunnicliffe didn't hold on to every book he did and most lists available from other sources have been found short of some titles. As an illustrator Tunnicliffe would take what pleased him and turn down what didn't. This, in fact, was what he did throughout the forty-five years he worked as a publishers' illustrator.

Henry Williamson's *The Star Born* had served a useful purpose so far as Tunnicliffe was concerned. It had taught him to shun things he couldn't understand. *Tales from Ebony* were

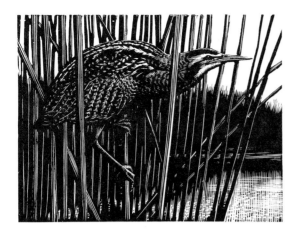

Bittern. Wood-engraving from
A Book of Birds, 1937.

Jay. Wood-engraving from
A Book of Birds.

something he really could understand for they were the classic fairy stories of Hans Andersen and Grimm, among others. The collector of these stories was the actor B. Harcourt Williams who had been very successful giving fairy story readings at matinees in one of the London theatres. The title of the collection – chosen by Tunnicliffe incidentally – was taken from the name of the actor's country cottage near Rye. Tunnicliffe's treatment was one of the finest and most sensitive sets of illustrations for Hans Andersen or Grimm that has ever been done. Here were no nightmarish, Grimm horrors but a good humoured assortment of colourful compositions in various styles, ideas from medieval manuscript illustration rubbing shoulders

Tweedside ploughing. Scraperboard from *Both Sides of the Road*, 1949.

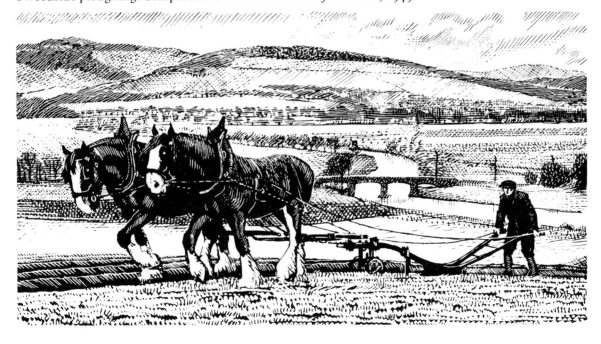

Original artwork for the cover of *Mereside Chronicle* (1948).

Original design for the cover of *Shorelands Summer Diary* (1952).

Widgeon. Scraperboard for *Farmer's Weekly*.

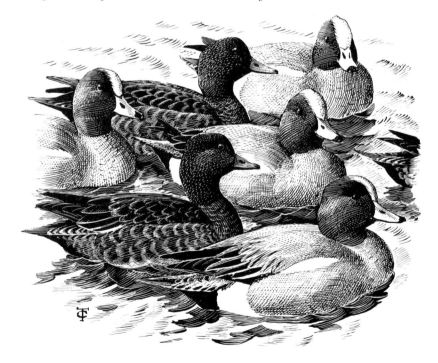

with Victorian grotesque and pastiches of Islamic art. Tunnicliffe himself smiled upon those fairy tale illustrations. They pleased him. He remembered them while a great many other commissions were quite forgotten. Putnams commissioned *Beasts Royal* for Patrick Russ and a book called *The Dull House* by Kit Higson. With all this there followed something of a lull after *Salar* in 1936, a Putnam book, *The Sky's Their Highway* by Kenneth Williamson (1937), and Mary Priestley's *A Book of Birds* in the same year. *Birds*, like *Tales from Ebony*, was something out of the ordinary. It was a wonderful anthology and it seemed to require only the embellishment of the work of a first-class wood-engraver. It was taken by Norman Collins at Gollancz who engaged Tunnicliffe as the artist. His publishers didn't spoil the ship for a ha'pennyworth of tar. For Tunnicliffe's 82 wood-engravings they used paper of the finest quality. For perhaps the only time in his career Tunnicliffe was able to say that his painstaking, eye-straining work had been done full justice. *A Book of Birds* was a beautiful volume, but sales were modest and Gollancz did not publish another bird book for forty years. Then Charles's superb *Sketchbook of Birds* (1979) re-established his connection with the firm.

Little Owl. Wood-engraving, 1956.

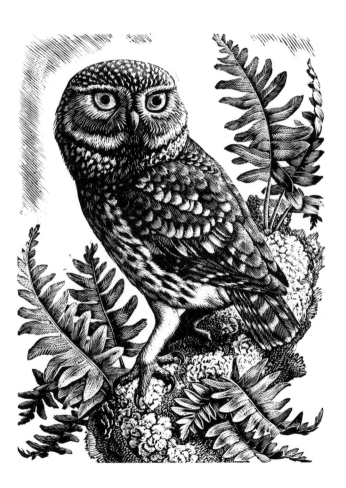

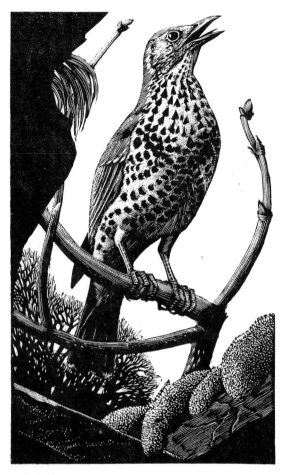

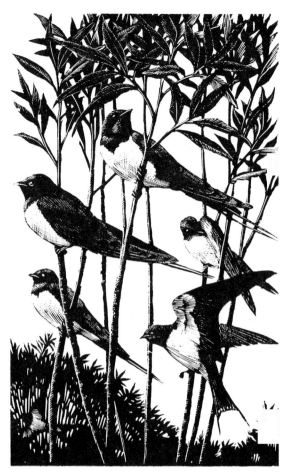

Missel thrush. Wood-engraving
from *A Book of Birds*.

Swallows in osiers. Wood-engraving
from *A Book of Birds*.

Where do I go from here? is the question everyone asks himself at different times in his
career. The war followed soon after *A Book of Birds* was published and everyone was asking
the same question. Not only was Tunnicliffe feeling the daily demands of his new profession
as schoolmaster but Government departments and organisations stemming from them
wanted his work. Everyone was being made aware of the importance of the land, stock-
raising, ploughing, sowing, reaping, mowing and producing eggs and milk. At the same time
Cambridge University Press went to work to publish a series of books on the seasons. H. E.
Bates was asked to do *The Seasons and the Gardener*, F. Fraser Darling wrote *The Seasons and
the Farmer* and *The Seasons and the Fisherman* while D. H. Chapman did *The Seasons and the
Woodman*. The restrictions of life in Britain at war made avid readers of a great part of the
population forced to suffer long vigils on gunsites, firewatching duties and so on, and
somehow paper and printing capacity were found to supply this need. Tunnicliffe illustrated
the four books by Bates, Fraser Darling and Chapman in 1940 and 1941. Later on he did
D. H. Chapman's *Farmer Jim* and then along came the work of Richard Church, author of

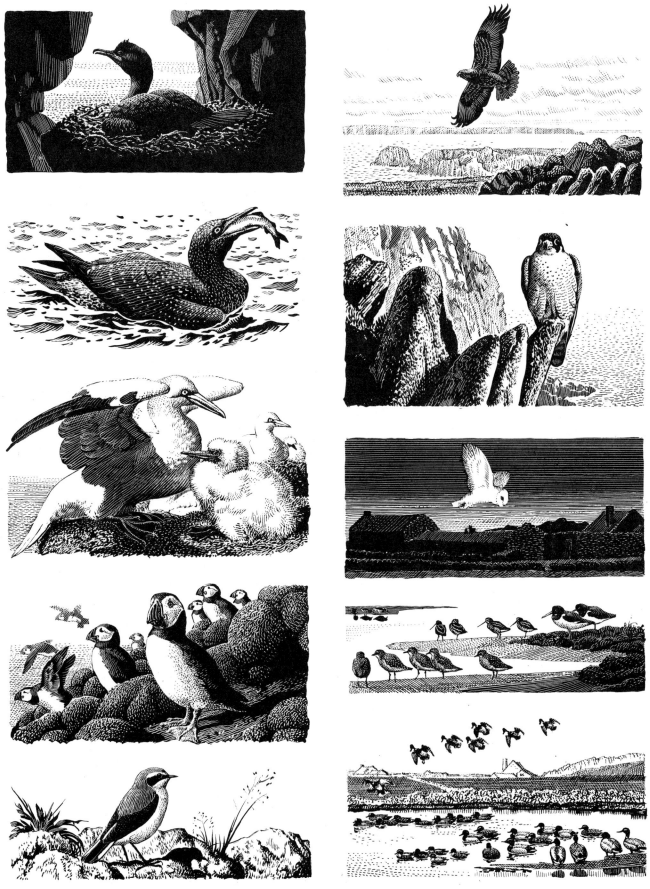

Scraperboard illustrations for *Letters from Skokholm*, 1947. Tunnicliffe made his
superb illustrations on a few large boards. This is some of his finest scraperboard work.

"He saw below him his own image."
'The Ugly Duckling' from *Tales from Ebony*.

"They all flew out of the window again as swans."
'The Six Swans' from *Tales from Ebony*.

"'Hello, little pig,' said the wolf."
'Three Little Pigs' from *Tales from Ebony*.

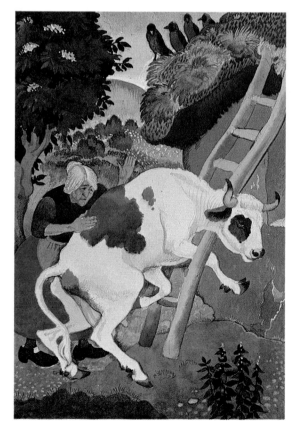

"But the old woman thought her way was best."
'The Three Sillies' from *Tales from Ebony*.

Wessex saddleback sow and litter. Scraperboard from *How to Draw Farm Animals*, 1947.

The Porch. Church had written *Green Tide*, a book Tunnicliffe really could say he understood, for he went off down south to stay with Church while he made sketches of the southern landscape of farms and oasthouses. Church and Tunnicliffe got on particularly well. They were both gentle, sensitive characters. Tunnicliffe remembered with amusement sallying out into the countryside to make his sketches with nothing more in his pocket to explain himself than a civilian's identity card bearing an address rather a long way from the fortress of the Home Counties and the expected invasion scene. Sketches he made again and again, although the subjects were certainly innocuous ones and it would have taken a very spy-conscious person with an overstimulated imagination to see anything else in them. No

Lincoln curly-coated sow. Scraperboard from *Both Sides of the Road*.

Cheviot sheep on their native hills. Scraperboard from *Both Sides of the Road*.

one came and asked him what he was doing even though a great proportion of the meagre resources remaining to the Army, reforming and reorganising after coming out of France, were gathered in France and Sussex. No harm was done. Tunnicliffe drew the shady trees, the green and pleasant landscape, and went off back home to Cheshire. He had pleased himself and he pleased that gentle man, Richard Church. A later book by Bates was more to his liking than *The Seasons and the Farmer* because it gave greater scope to both the talent of the author and his chosen illustrator. "I have no fixed ideas for Tunnicliffe," Bates is recorded as saying. "It seems to me that the most pictorial bits of the book will probably please him – the fisherman, the swimming snakes, kingfishers, cornfields, birds feeding on seeds and so on. He is very good and I think will do a good job." The book was called *The Heart of the Country* and it came out in 1942. Tunnicliffe later on did *O More than Happy Countryman* for Bates.

Things were moving in the right direction if Tunnicliffe could contemplate making a living entirely as an illustrator of books. After that third attractive book for Bates, *Country Life* suggested that Negley Farson's *Going Fishing* was something that Tunnicliffe might consider. Farson's book was a fisherman's delight, a classic of its kind written by a brilliant journalist, but Tunnicliffe hadn't been to the wilds of Canada. Even if wartime restraints and difficulties could have been eased he was hardly likely to be paid to go half way across the world to do a few drawings! He certainly hadn't much chance of taking his sketchbook to the places in Europe Farson had visited while gathering his material for the book. Such places were either in the hands of the Germans or were being disputed by partisans. Farson solved the problem by supplying dozens of photographs. The work was very dear to Farson's heart. He had lived to fish. Tunnicliffe set to and produced another set of scraperboard illustrations.

Scraperboard illustrations for *Letters from Skokholm*. Another single board crowded with excellent designs.

Golden plover. Scraperboard for *Farmer's Weekly*.

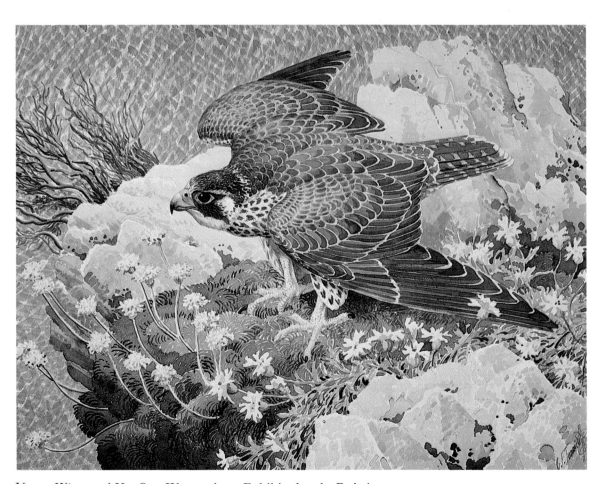

Young Wings and Hot Sun. Watercolour. Exhibited at the R.A. in 1949.

When Farson saw the result he wrote to say he had been filled with nostalgia for a particular stream in Devon. He was equally pleased with all the other illustrations Tunnicliffe had provided. *Going Fishing* has recently been reprinted. It was always collected by fishermen and indeed by a lot of people who never cast a fly in their lives. It was not only beautifully written but wonderfully interpreted by Tunnicliffe.

The end-paper maps for *A Norfolk Farm* were the last thing Tunnicliffe did for Williamson until he did some small drawings for the paperback *Tarka* in 1963, but not the last thing Tunnicliffe heard of the books he had illustrated. Years afterwards an American publisher approached Tunnicliffe with the suggestion that he might do the same thing over again and supply illustrations for a kind of 'Best of Henry Williamson' project. The research had been done, the rough sketches might have been worked over, and changed a little. Scraperboard would be acceptable if Tunnicliffe now declined wood-engraving, but Tunnicliffe had no taste for any of it. So far as he was concerned this was where he had come in. He didn't want to sit through it again, however chastened Williamson might have been after their earlier conflict. Romantics and intellectuals bothered Tunnicliffe. He was not impressed by names as much as by the work, and he had to have a feeling for the thing he was asked to do. This applied when another American publisher came along with the suggestion that he should illustrate the works of T. H. White. The publishers wanted drawings for *The Sword in the Stone*, *The Goshawk*, *The Ill-made Knight* and *The Witch in the Wood*. Tunnicliffe told me that he found himself a little baffled to know what White was getting at sometimes. He didn't want to 'interpret' White without knowing what he meant. He felt that he must draw what he could 'see' and what he couldn't see he had better not attempt, which, one feels sure, would have appealed to White as a very honest judgement – a lack of

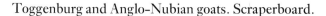

Toggenburg and Anglo-Nubian goats. Scraperboard.

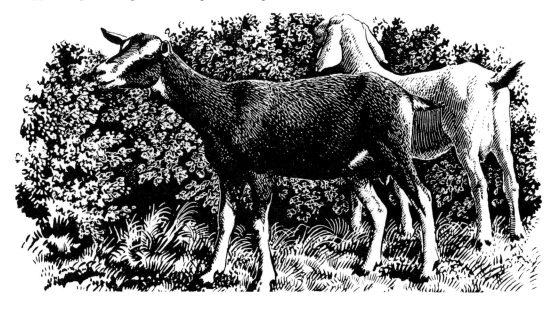

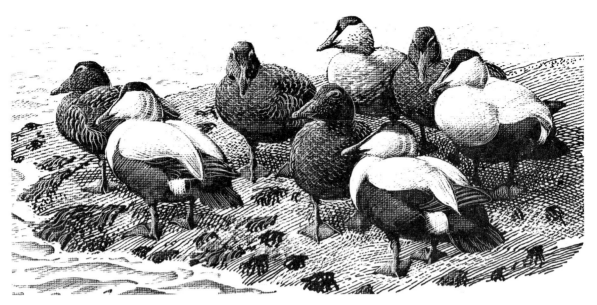

Eiders on rocks. Screened scraperboard.

communication. Tunnicliffe no doubt remembered *The Star Born* and the difficulty he had once experienced in getting into the realms of fantasy. He declined the commission.

In addition to his work for Williamson, Tunnicliffe only illustrated two other books with wood-engravings: *Wild Life in a Southern County* by Richard Jefferies and Mary Priestley's *Book of Birds*, previously referred to (he used to run off individual prints from the blocks and sell them for a guinea each). All the other books were illustrated with scraperboard or line and colour work. In 1947 Eyre and Spottiswoode asked Tunnicliffe to undertake the illustrations for Terence Horsley's *Fishing and Flying*. The fishing part presented no problem (Charles was an experienced fish-watcher) but the flying was a different matter. Tunnicliffe was quite familiar with the camber on the wing of a bird brought to him for one of his post mortem drawings. In a note he explained the difficulty in drawing the bird's wing in plan view because of the camber, but aerodynamics were not part of his everyday research, and off he went to Avro's in Manchester to see exactly how a manufactured wing achieved the miracle of mechanical flight. Terence Horsley was a well-known figure in the world of journalism and he was also very much involved in the business of gliding. Soon after *Fishing and Flying* was on the drawing-board *Country Life* offered another book by Horsley, *The Long Flight*, and Tunnicliffe supplied the illustration for this one too. Both books appeared in the same year, 1947. Horsley met his death in a tragic accident involving a glider soon after his books were published.

Not everything that came was grist to the mill or Tunnicliffe would not have turned down the more lucrative propositions from America, but he did undertake a prodigious amount of

illustrating that gave rein to his special talent for drawing animals and birds. One aspect of the work that surely explains why he forgot so many of the people whose books he illustrated, and why he failed really to see what he was doing, was the urgency imposed by the demands of the printer as well as the publisher. Often a full page drawing or set of chapter heads and tailpieces would hardly be off the drawing-board and on the way to the press before a new set of roughs for something else was being prepared. With commissions following one another and the inevitable time lag between the work being delivered and the book appearing on the bookstall, perhaps a year later, it was always the latest thing that was in his mind. It was hard to recognise things as a package. He enjoyed the work and rarely had difficulty over any of the things he was commissioned to do. He had a special feeling for *Our Bird Book* (1947) and *Both Sides of the Road* (1949) and he enjoyed doing Brian Vesey Fitzgerald's *Rivermouth*, also in 1949. The 1950s were busy years too and during this time along came the work of the great man of the bullfights, Ernest Hemingway. Tunnicliffe and Hemingway belonged to very different worlds, but both were interested in the bullfight, even if Tunnicliffe had never been to Spain to witness the corrida or hear the warning trumpet in the *plaza de mala muerte*. With his talent for drawing one wonders what dramatic illustrations of the bullfight Tunnicliffe might have brought back from Seville or Madrid had he gone there, for the bull featured in some of his most impressive etchings, line drawings and paintings. Hemingway's English publisher didn't suggest the Spanish scene and was quite unaware of Tunnicliffe's interest in bullfighting. It was the Gulf Stream and the world of the wave-skipping flying fish, the marlin, the bonito and a vast sky far removed from the Cheshire hill country and Anglesey. *The Old Man and the Sea* may have had more than a suggestion of allegory about it, but for Tunnicliffe the old man was real enough. So was his quarry. There was some research to be done of course. The boat, the fisherman, the fish, and the sharks that stripped it to a skeleton, had to be right. Tunnicliffe accepted the commission without being aware that due to a misunderstanding with a book club the publisher had inadvertently offered the same job to

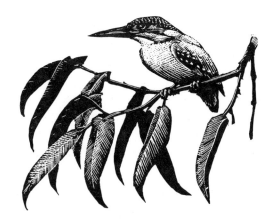

Kingfisher. Wood-engraving from
A Book of Birds.

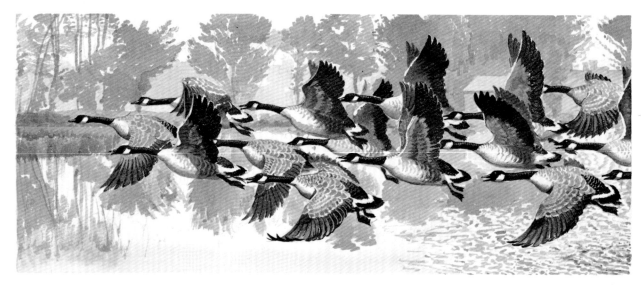

Canada geese leaving for the upper pool, Redesmere and Capesthorne (*Mereside Chronicle*).

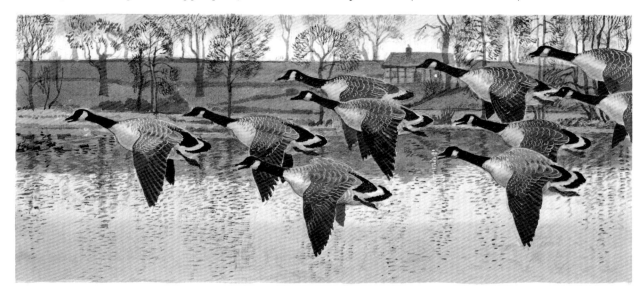

Canadas gliding to the water, Redesmere (*Mereside Chronicle*).

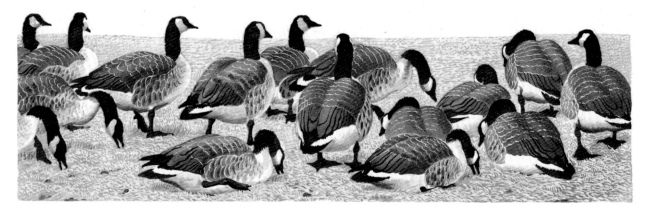

Canadas in the frost, Redesmere (*Mereside Chronicle*).

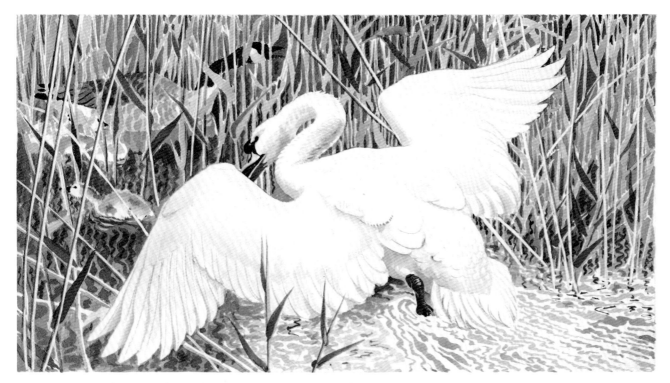

Angry cob attacking Canada family, Redesmere (*Mereside Chronicle*).

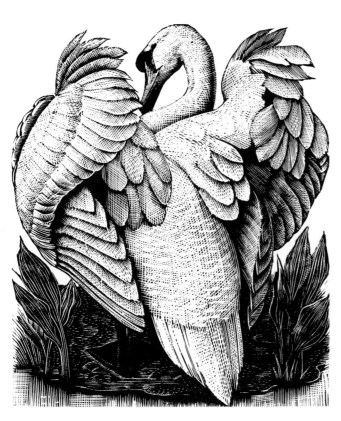

Swan from *A Book of Birds* (wood-engraving).

Suffolk ewes. Scraperboard from *Both Sides of the Road*.

American golden plover from *A Book of Birds*. Searching for a specimen of this bird to make his study, Tunnicliffe visited Reg Wagstaffe at Stockport Museum for the first time. By an extraordinary coincidence, a dead American golden plover lay on Reg Wagstaffe's desk as Tunnicliffe called. This is the bird.

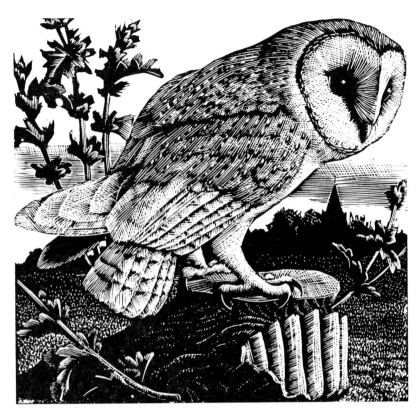

Barn owl from *A Book of Birds*.

another artist, Raymond Sheppard, simultaneously. Tunnicliffe got on with his part and delivered his work. Raymond Sheppard, too, got on with his. When the dreadful truth was revealed to the publishers they bravely decided to press on with both sets of illustrations willy-nilly. Both artists were startled to discover they had shared the work. Sheppard wrote to say how sorry he was to have been involved. Tunnicliffe wrote and commiserated with him. Neither remarked how fortunate the publisher was that there had been no serious clash of style. The book was awkwardly broken up with so many drawings by one artist intermingled with so many by the other. In spite of this, it is a very fine volume which shows a fascinating variety of illustration by two masters of their craft.

In the 1960s Tunnicliffe did fewer books, picking and choosing the work that appealed to him, and turning away books for which he had no feeling. A book on deer appealed because he had always enjoyed watching them and he had a feeling for the subject, and so he did Arthur Cadman's *Dawn, Dusk and Deer*. Three books of my own interested him and he did *The Way of a Countryman*, *A Galloway Childhood* and *A Fowler's World*. The last two major

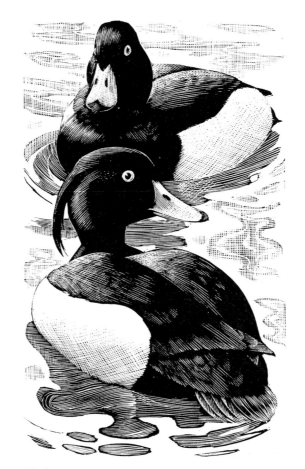

Tufted ducks. Wood-engraving from *A Book of Birds*.

Coot and bream at Redesmere (*Mereside Chronicle*).

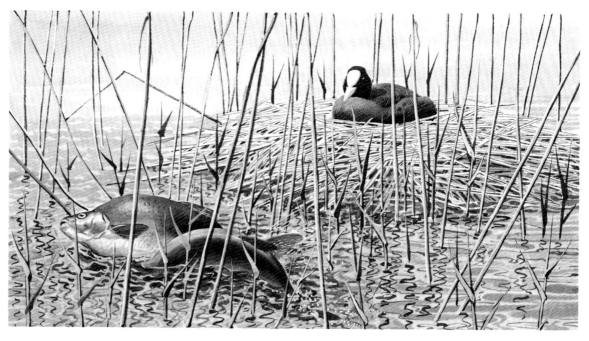

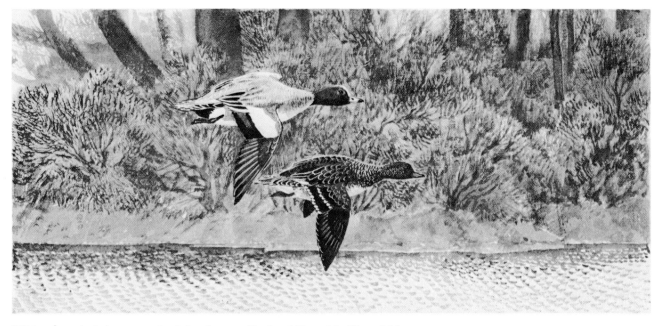

Widgeon pair flying past the Island trees, Bosley (*Mereside Chronicle*).

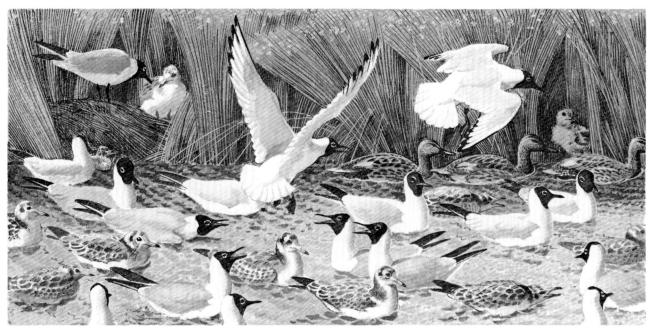

At the gullery, Oakmere (*Mereside Chronicle*).

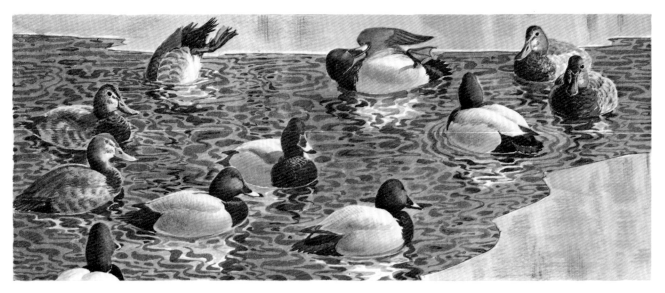

Pochard at Bosley (*Mereside Chronicle*).

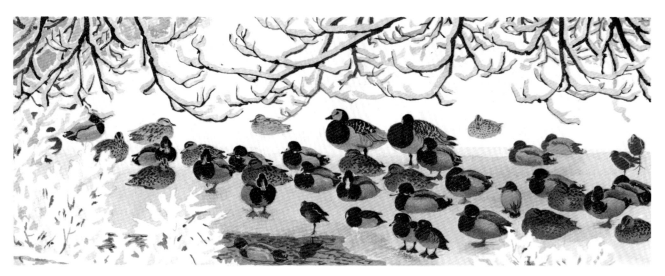

Almost frozen out at Gawsworth (*Mereside Chronicle*).

Young rook with an injured wing
(*Mereside Chronicle*).

Bream in the shallows, Redesmere (*Mereside Chronicle*).

illustrating commissions he accepted were for myself and R. M. Lockley. Both of these books were published in 1977, and the last things in the long list of titles he worked on over the forty-five years. Few if any of the forty-odd authors or editors, and few of the publishers involved – and there were a score of them or more – had cause to complain that Tunnicliffe had done them less than justice. He was a painstaking and very conscientious man quite incapable of saying that near enough was good enough in anything.

Alison Uttley thought no one else could so well illustrate her books and year after year asked Tunnicliffe to do yet another. Since he did no less than two dozen children's books in the course of his career he could claim to have been an educator of the young generation in both natural history and botany. Charles's old friend, T. G. Walker, has well assessed his work as an illustrator:

Charles was a perfectionist. The only time when he showed anger, when he flared and fumed, was when a publisher ill treated his book illustrations. An illustration might have suffered a cut along the top or bottom or side, thus destroying the balance of the

composition and spoiling the picture in his view. I remember his fury at such treatment from the publishers of a children's book. He wrote to them straight away to inform them that he would not undertake further work for them! He was an artist who would not abandon his high standards for any price.

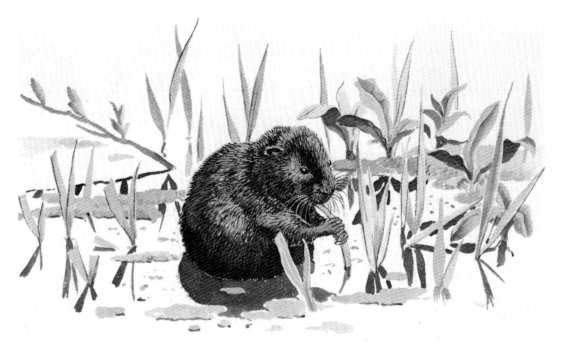

Water-vole feeding (*Mereside Chronicle*).

~7~

Field Sketches
and Post Mortem Drawings

TUNNICLIFFE'S UNEQUALLED SUCCESS as a bird artist depended more than anything else upon the reference he accumulated over many years in his field sketchbooks and post mortem drawings. The already published *Sketchbook of Birds* (1979) gives only a small indication of the extent of the work. At the end of his career he possessed fifty major field sketchbooks and several smaller ones but he had probably given away many others. His post mortem drawings exhibited at the Royal Academy in 1974 revealed the tremendous industry of the man and the enormity of the task he embarked upon in 1938, when he began. Years before he moved to Anglesey he was searching out birds in Cheshire in places he had known since boyhood as the haunt of particular species. On the meres he found waterfowl. On the river Dane he found the kingfisher and the dipper. On the moss he found his owls and many lesser birds which, when he moved to Wales, he might have found harder to discover. Soon Winifred brought him his first post mortem, a duck from the market in the Manchester Shambles. One day in the course of making his field sketches he encountered a young bank clerk who was equally absorbed in the bird life of the meres. John Clegg from Wilmslow understood Tunnicliffe's need for an authority who could put him right on ornithological details. Tunnicliffe didn't want his finished work to be merely a painting of a bird, or group of birds, in a natural setting; he strove also for absolute accuracy. There were many questions he needed to ask and many pitfalls to be avoided. John Clegg put Tunnicliffe in touch with Reginald Wagstaffe, Curator of the Stockport Museum, a man with a unique knowledge of birds as a result of the extensive field work he had done. The two men took to one another perhaps because Tunnicliffe's approach to his subject was such a meticulous one. There was no easy answer to Tunnicliffe's problem, however. He had to become as sound a man on birds as he was on the principles of sketching and painting them. He had to become an ornithologist and acquire through field study what he simply couldn't get from books. Reginald Wagstaffe sent his pupil birds that had arrived at Stockport for examination – post mortem work which Tunnicliffe dealt with in his own way, carefully measuring and recording in pen and colourwash, the swift that arrived one day, a wheatear the next. He had

Boats on the shingle at Moelfre, Anglesey.

Ruin on Anglesey, pen and ink sketch. Tunnicliffe had studied the work of David Cox, who published a treatise on landscape and architectural drawing in 1814. Cox's influence is apparent in this fine study.

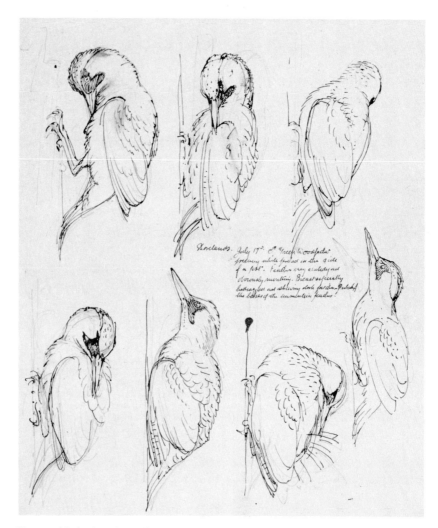

Pen and ink sketches of a green woodpecker.

the guidance of Wagstaffe on varieties and plumage. He asked questions and got answers. Wagstaffe was a scientist and he not only educated Tunnicliffe in the subject, but taught him also to be cautious in his approach.

The field notes and sketches covered over forty years of Tunnicliffe's life. Had he not kept a personal diary he could well have told a friend exactly what he was doing on a particular day in spring in the year 1940 or 1948. Wherever he went, he sketched, not only in Cheshire and Anglesey but in his beloved Scottish Highlands, the Fens, and the island of Skomer off the coast of Wales. No reference book could have provided his raw material. Text cannot elaborate upon itself. Tunnicliffe made his notes and they stood beside what he had drawn but there was always Wagstaffe to confirm that what he had recorded was what he named it and vice versa. Tunnicliffe knew from his early days as a student that an artist is only as good as his reference. He observed and sketched birds with dedicated passion from 1934 until he could see no longer.

In *Bird Portraiture* (1945) which he produced as an encouragement to the student, Tunnicliffe tactfully suggested that the beginner might start by drawing the birds of the farmyard. He knew that fieldwork was essential but a too ambitious approach could prove disappointing. He was thinking of one of the most notable American bird artists of another century who had made considerable use of stuffed birds to an extent that it showed! Tunnicliffe's post mortem drawings were executed with meticulous care. He never had time for taxidermal subjects. Although he drew and painted a great many raptors and pastoral birds, waterfowl turned out to be his particular subject, largely because they were there, firstly on the meres in Cheshire and later outside his window when he set up his studio at Shorelands on the Cefni Estuary. He could never resist the graphic note that went beyond what he had drawn or painted, and what he had to say added to the general sum of knowledge of those privileged to read his note. Indeed, had he thought to do so, he could have produced a fascinating book on bird behaviour. He watched oystercatchers hunting shellfish in the tideline and recorded how they went in up to their breasts in the turmoil of the water, even as a wave broke, and tugged hard to disengage a shellfish from the weed to which it had fastened itself, finally bringing it out of the water to eat it. He noted that herring gulls regurgitated castings of oats found on the field and how a gull demonstrated that it had a memory. A crust he threw fell into a crevice. The gull made no attempt to get it, but twenty minutes later, when the artist had withdrawn, it went down and extracted the titbit from a cranny in the rocks. Another day he mentioned how a heron slipped in the mud. Its feet were heavily coated with silt and it periodically threw out a wing to recover its balance. The shelduck beside this same brook, on another day, fed in the shallows while one of the number seemed to stand guard.

His observation was always extraordinarily acute. Nothing escaped his eye. He had watched such commonplace events as a gull breaking up a crab with crows hovering nearby, and knew how the crows would fool the gull, one tweaking its tail and retreating while the other stole the crab when the gull went after its tormentor. Such notes, recorded in his sketchbooks, undoubtedly stimulated his imagination when, later on, he made a cartoon from the sketchbook and finally did a painting for a gallery or the Academy. Everything was grist to his mill. He picked up a dead cormorant on the shore, noted that it had been shot through the breast, and thinking that he saw the bird's tongue, opened the bill and extracted a flatfish 'eight inches in length and three inches across'. The cormorant, which he took home and dried, was in transitional plumage, 'clothed in a mixture of old and new feathers'. The scapular feathers were illustrated in this state. The notes tell the sad story of geese harried by shooters. A friend of Tunnicliffe's had been responsible for establishing colonies of both greylags and Canadas on Anglesey and both men delighted in watching their comings and goings. Wildfowlers had a different delight, however, and not a few of these non-migratory geese were shot within sight of Tunnicliffe's window. On one occasion a shot bird was left lying, half dead, on the sand and its pathetic calling lured its mate back to face a second volley. A wounded Greenland whitefront joined the geese on a nearby farm, only to be pursued later on, when it had been half domesticated, by the man who had shot it before. Tunnicliffe recorded the bird's end without comment but his fury made him speechless years afterwards.

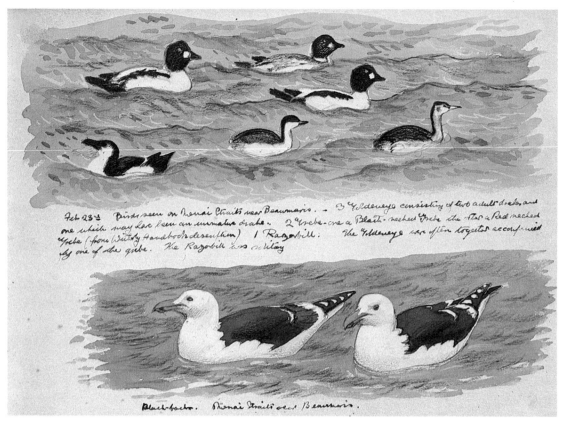

Birds sketched in February c.1946 on the Menai Straits near Beaumaris, Anglesey, including goldeneye, black-necked and red-necked grebe and a solitary razorbill.

Pintail display sketched in March *(above)* at Cob Lake. *Below* Goldeneye in front of the house.

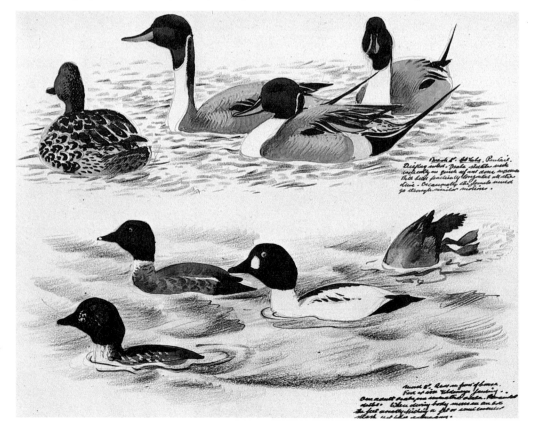

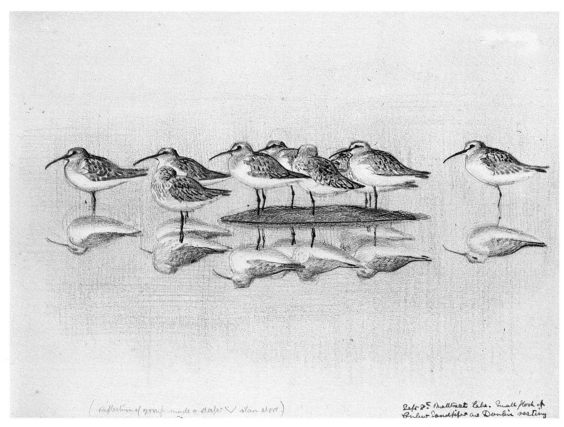

Curlew sandpipers and a dunlin resting at Malltraeth Lake, September c.1950.

Flock of knot sketched in February as they rested on waste ground near the River Mersey.

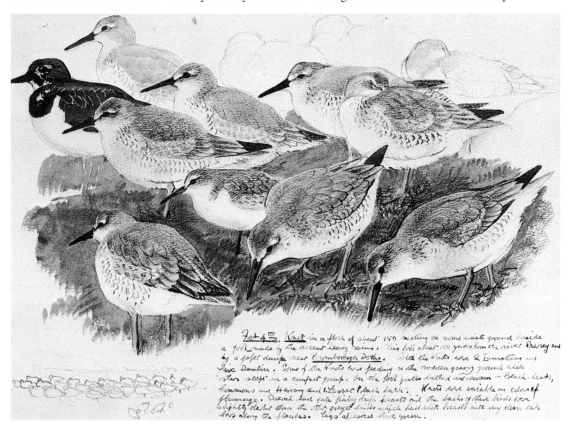

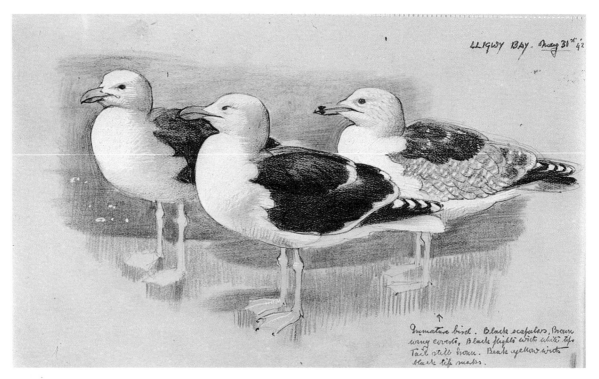

(Above and opposite) Great black-backed gulls sketched at Lligwy Bay and Moelfre
Rocks, Anglesey, 1942.

The occasions for making important sketches and notes were almost without number.
Birds were not the only creatures brought to Shorelands. A boy came with an adder from the
nearby dunes and the Tunnicliffes gave it sanctuary – in their bedroom. The girl who made
the beds and tidied the room refused to go in there. Tunnicliffe made some extraordinarily
fine sketches of the snake, coiled, docile, and poised, ready to strike, and then turned it out of
doors. He and his wife had failed to make it take food in the way a goose is persuaded to make
paté. It was happier in the warmth of the compost heap, but there it died.

Although he never went abroad Tunnicliffe was fascinated by the landscape and the birds
of the Scottish Highlands. He made several visits to the rugged shores of Handa Sound,
Tarbet and Lochinver where he once sketched the great northern diver and recorded how it
would bolt a crab with the crab's legs sticking out of the sides of its bill until it managed that
final gulp down. Two days later he saw the same bird again and noted the progress of its
moulting. There was 'an increase in the spots on its wing coverts and mantle. The white neck
band was more apparent'. At this place he was convinced that bullfinches he saw beside the
Mackenzies' hen run were larger birds than those he had seen elsewhere. He suggested they
were of a northern race. He drew the Great Skua at Achmelvich Bay, noted how it rose with
legs dangling and how it washed its head, dipping it in the water while maintaining a vertical
position in the air. This skua lived by harrying common terns whenever they caught a fish.
He was able to compare it with another specimen brought to him all the way from Antarctica
by a young scientist who had been on the *John Biscoe*. Tunnicliffe fed the skua and finally

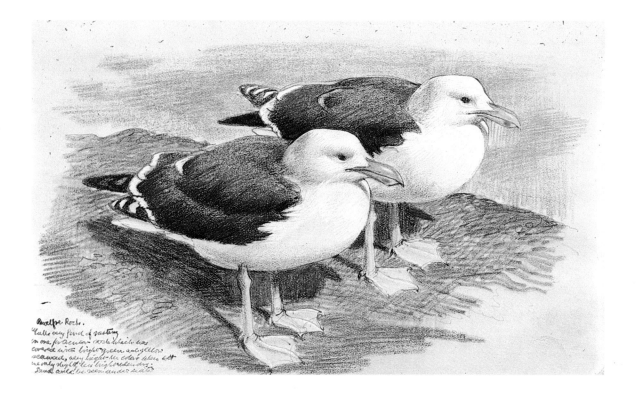

Onalfre Rocks.
Yulls very fond of roosting
on one particular rock which was
covered with bright green and yellow
seaweed, very bright, the colar when wet
was only slightly less bright when dry;
Sand could be seen under water.

passed it on to the Chester Zoo after he had made all the sketches he wanted.

Steadily Tunnicliffe went on and on, filling sketchbooks with colour-washed and chalk drawings of superb quality. He went to East Anglia for the marsh harriers at Dimwich and compared what he saw with Montagu's harrier. He sketched bitterns from a hide and noted how the hen bird tried to get a chipping egg under her, and how she tried to weave a piece of reed into the general fabric of the nest. There were bitterns on Anglesey of course and later on, although he didn't find their nests, he came up on one in the reeds by stalking it through its ponderous snoring which is the bittern's prelude to its booming. Avocets were less frequently to be seen on the Cefni Estuary than at Havergate Island in East Anglia where he watched the female 'slicing with her tail raised' while the male beside her threw water from his bill. He sketched them mating and observed that when copulation was over they strode along together and momentarily crossed bills before walking away from each other. Nest-making was illustrated by the bird forcing its breast to rotate while wings were held clear to produce the motion of rotation.

All through Tunnicliffe's sketchbooks there are notes of this kind and reading them one is inclined to miss entirely the fact that this work was only part of his very full day. He would return from the field, complete his pen and colourwash, put the finishing touches to his chalk drawing, taking account of the colour notes he had made, and then go on to work on scraperboard for the publishers, advertisement illustrating work for the agency, and perhaps a post mortem he found lying waiting for him when he came back. Quite apart from his art he was absorbed in the small things of a countryman's world and so when someone brought him

a very fine Indian gamecock and asked him to draw it he took note of the fact that the great cockerel stood on treelike legs that were far apart. It had been hatched from the egg on May 6th 1944. When it was drawn for the pot, soon after it was drawn for the sketchbook, it weighed 8 lbs 10 ounces, a most remarkable specimen considering it hadn't been caponised. Tunnicliffe was still filling sketchbooks in the period between 1967 and 1970 soon after his wife died. They were his 'stock in trade' as Tunnicliffe's fellow artist and friend Noel Cusa has recalled, when it came to doing commissions for galleries or private buyers.

In June 1972 Tunnicliffe's close friend, Kyffin Williams, R.A., who lived near him on Anglesey, persuaded the Royal Academy Council to put on an exhibition of the post mortem drawings and some of the sketchbooks. This was a bold decision by the Council. Although Tunnicliffe's six pictures a year were always acclaimed at the R.A. Summer Exhibitions (and traditionally all sold on the first day) his post mortem work had been seen by only a few people and his sketches only glimpsed in his wartime books, *My Country Book* and *Bird Portraiture*. There were a number of problems: insurance, selection, cataloguing and display, and the distinguished ornithologist Dr Bruce Campbell was enlisted to sort the drawings out and prepare a catalogue. Kyffin Williams had the unhappy task of making a valuation of the work for insurance purposes. There really was no sum that could be put on it. Tunnicliffe's life's work was priceless and could certainly never be replaced. At last, in the summer of 1974, the exhibition was staged in the Diploma Galleries of the Academy.

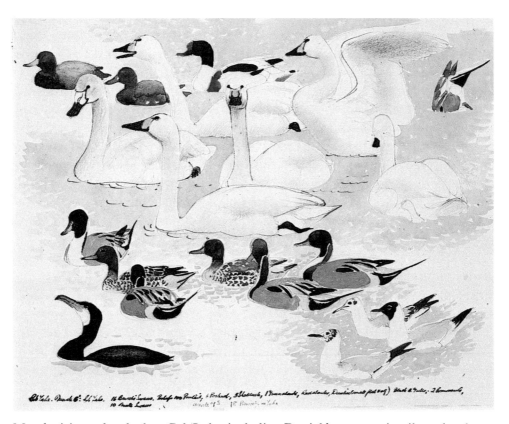

March visitors sketched on Cob Lake, including Bewick's swans, pintail, pochard, shelduck, black-headed gulls and a cormorant.

People travelling on the London Underground that summer might find themselves look-ing at a very fine poster of one of Tunnicliffe's post mortem drawings, but even those who made their way to the Academy could hardly appreciate what the exhibited drawings really signified. They were the result of a vast network of communication between Tunnicliffe and people who supplied him with specimens. Scores, even hundreds of people who found dead birds, injured birds, nestlings fallen from the nest, or victims of some other kind of misfortune, parcelled them up and sent them to the Tunnicliffes. There was as much fascination in post mortem work as Stubbs had found when he struggled with his dead horse. In Tunnicliffe's case the plumage reference was perhaps the most important, although he needed to be informed about the proportions of the leg of a cormorant or even a wren and he needed to be able to paint the beak of a puffin or a nightjar as accurately as he might paint that of a curlew or a shoveller duck. There was also the problem of sexing birds. Here the simplest thing to do was to use the scalpel, but the finality of that deprived the artist of any further opportunity of drawing the 'feather map' and the Tunnicliffes resorted to the old way of sexing with a needle dangling from a length of cotton or using a gold ring in a similar way. This kind of 'witchery' would have been scorned by Reginald Wagstaffe, Tunnicliffe told me with a smile, but it worked. He and his wife made many tests, divining the sex of a bird by the needle and confirming their finding with the scalpel. A relative on one occasion brought them a clutch of eggs which he had carefully had checked out, some being infertile, and was

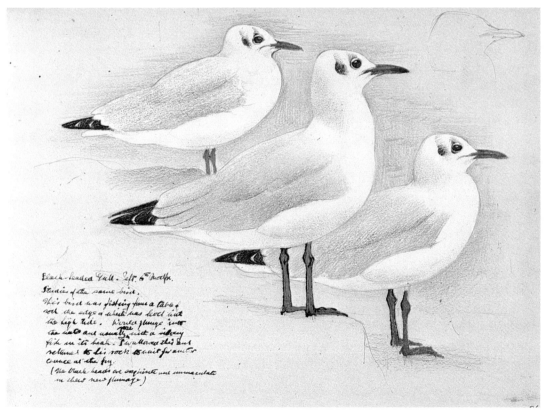

Sketches of a black-headed gull, Moelfre, September 6th, c.1950.

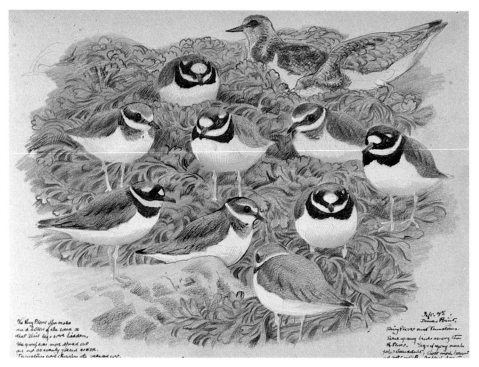

Group of adult and immature ringed plover with turnstones behind, sketched at
Dinas Point, Anglesey, September 7th, 1944.

astonished when the Tunnicliffes culled the infertile eggs from the clutch without making a
single mistake. It needs to be emphasised that Charles Tunnicliffe didn't have any time for
the 'fey' and didn't believe in witchcraft. He was much more inclined to accept the evidence
of his eyes, but a curious thing came of the use of the needle to sex birds. As every
ornithologist knows when drakes of certain species of duck come into the moult they pass
through what is called eclipse and for a time the male assumes the plumage of the female.
Sexing dead birds was automatic with the Tunnicliffes. It had become a standard procedure.
When Kyffin Williams brought him a pochard drake in the first stage of the moult the post
mortem bird was sexed with the needle. The change in a bird in eclipse, like the growth of
fingernails on a corpse, continues after death. When the pochard was checked later on the test
proved 'neutral' and still later, female. The interesting thing is that there would seem to be a
middle period when the hormone balance is equal and a period afterwards when it becomes
female. In a living bird the hormone balance adjusts finally back to male and the eclipse is
over. This was something that intrigued Charles Tunnicliffe at the end of his life. Scientist or
not, and few scientists would think anything of the needle test except as an old wives' tale, he
felt he was on to something about eclipse change in waterbirds and that the mallard drake,
deserting his mate and skulking on the remote headwaters of a stream, is no longer a drake
during that period of high summer but a duck.

The notes to the post mortem drawings credit the source of the material and in a
fascinating way give background to Tunnicliffe's mode of life. He was at home to anybody

who knocked on his door bringing dead or injured birds. He eagerly gathered in every specimen that came his way and it made no difference whether or not he had had a particular species before. His excitement at being able to complete a sheet on a particular bird was predictable but he knew too much about the vastness of the undertaking not to be resigned to the fact that some specimens might never come his way. His record of the wheatear, for instance, is of cock birds only. For some reason no one ever brought him a female. Perhaps the survival rate in cock birds was much lower than in females. He often completed a sheet on a comparatively rare species and did without a more common one. He never recorded the male ringed plover, for instance. Birds came according to the season and according to the activity of farmers, wildfowlers, migratory movements, gales and so on. The mass of sheets, hundreds of them, were accumulated in a number of portfolios which he would bring out when a new specimen arrived. He checked what he had done before, and revised his measurement here and there with a bit of fresh detail work. On the starling sheet he left a space for a head of a juvenile but that bird never came. Sometimes, rare birds like the glossy ibis or the snowy owl, shot by ignorant wildfowlers, would turn up at Shorelands. The little egret, found dead on the shore, was a real treasure. Charles meticulously drew them all. His notes would have pleased a scientist. Who could argue with a man who actually measured and carefully drew the tiny claw of a goldcrest, who spread the primaries of its wing and the feathers of its tail and painted them in such lifelike fashion that when he actually stuck the real feather on the paper the painted one seemed just as real and able to be lifted from its place? The work continued, of course, after the Academy Exhibition in 1974 and for almost another five years. New sheets were added and old sheets completed. It was not just a record of the native birds of Britain but a post mortem record, which meant that occasionally more exotic specimens crept in, and people brought him waterfowl from their private collections and cage birds from their aviaries.

One of the most remarkable things about these post mortem studies is the way in which Tunnicliffe managed to make the subjects live. He had a particular talent for bringing them to life and it was not just a touch of light in a dead eye but a quality of living and breathing that was uncanny. When he chose to draw a dead bird as a dead bird he drew attention to the

Studies of lobster and crab. Watercolour and pencil. Probably done in the early 1950s.

fact, but when he wished to simulate life and resurrect the dead he could do so. One group of remarkable post mortems not included in the portfolios adorned the walls of the studio at Malltraeth at the time of Tunnicliffe's death. They were tropical birds all of which had been drawn from dead specimens and every one of which had a kind of bright life about it, as though Tunnicliffe had gone to draw them in the aviary or had gone to some tropical rain forest to discover them in their natural surroundings – something to be said for a man who despised taxidermy and the kind of bird art deriving from a study of stuffed specimens!

Turning over the sheets of his portfolios is as fascinating as reading the work of great naturalists of an age gone. One realises that this is a unique collection as well as a life's work. The page on the shoveller records that Winifred bought such a bird from the market in Manchester in 1939. It was checked out and the data supplemented by material added when Tunnicliffe obtained another shoveller, when one was shot and brought to him from Newborough on Anglesey in 1956. There were many other birds recorded from many different places. A ring ousel came from Three Shires Head in Cheshire. It was a juvenile. An adult came from Cutthorn Hill in East Cheshire. The same man provided both. He was a gunsmith and a shooting man, but there was no record of how he came by the birds, and Tunnicliffe, although he never encouraged anyone to 'collect' birds for him, knew that he really couldn't help his work along by asking questions. A dead bird could only be buried or left to rot. He buried them, when he had drawn and recorded the particulars by measuring them and spreading their wings to do so. Sometimes wounded and injured birds were brought to Shorelands and most found their way on to the post mortem records and occasionally, with the loving care of Tunnicliffe and his wife, managed to find their way back to the marsh or the bush.

Measured drawing of a female green woodpecker, February 1954.

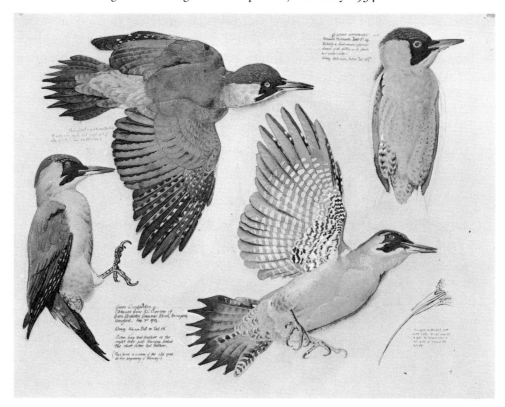

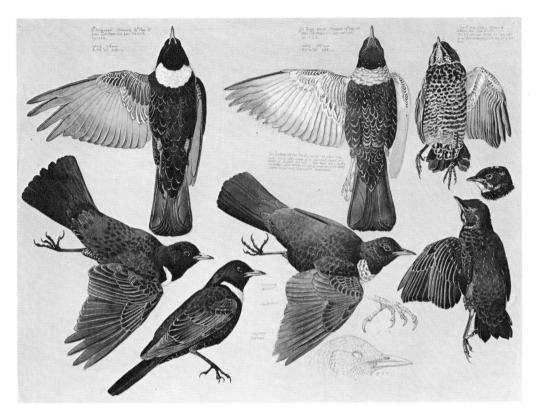

Measured drawing of a pair of ring ouzel with a juvenile, May 1965.

There was another post mortem record of much smaller dimensions dealing with animals, and Tunnicliffe lavished the same care on the post mortems of the weasel, the otter, the badger, the squirrel and the hare. While one day his post contained a nightjar picked up on the road between Abergavenny and Pontypool, the next day the local vet, Eileen Wheeler, would bring him a dead stoat for his file on quadrupeds. It was another day and another subject. Kyffin Williams had the measure of Tunnicliffe when in paying tribute to him in that catalogue of the 1974 exhibition he wrote:

His apprenticeship over and equipped for the task that lay before him he settled down to fifty years of observation, study and craft that has occupied every day of his life and made him one of the most internationally known names in the world of ornithological art. . . . a few years ago the distinguished Argentinian bird artist, Axel Amuchastegui, held an exhibition, and begged he should be enabled to meet Charles Tunnicliffe since he had always considered him to be his master. They met and Tunnicliffe said that if this was so he reckoned him to be his best pupil . . . Our bird-life is certainly threatened by the demands of modern times and this is one of the reasons why this amazing record created by the countryman from Cheshire is so important. The drawings are important because they show the art student what real hard work and dedication mean; they are important because of their scientific value, but above all they are important because quite unintentionally they are works of art.

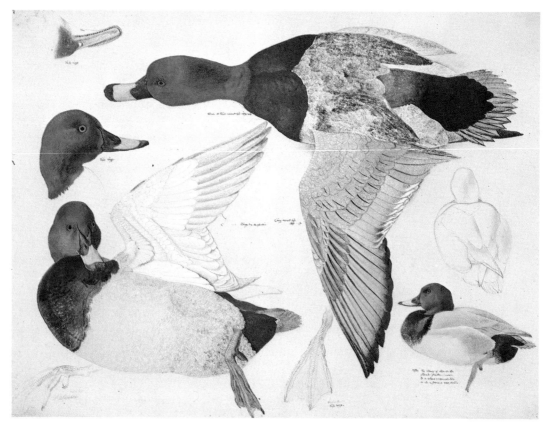

Measured drawing of a pochard drake obtained from the Manchester Shambles, February 1939.

Measured drawing of a cock golden pheasant from Norfolk, January 1959.

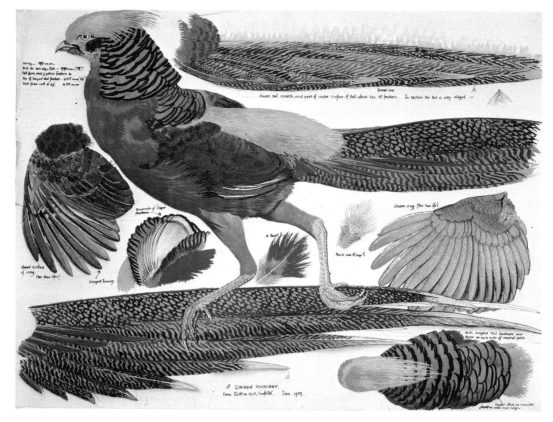

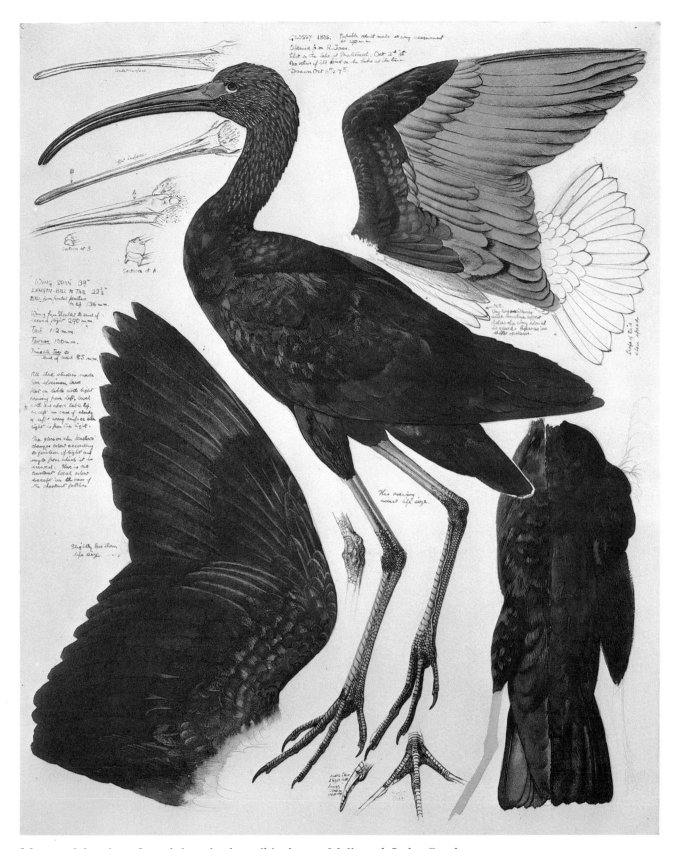

Measured drawing of an adult male glossy ibis shot on Malltraeth Lake, October 1945.

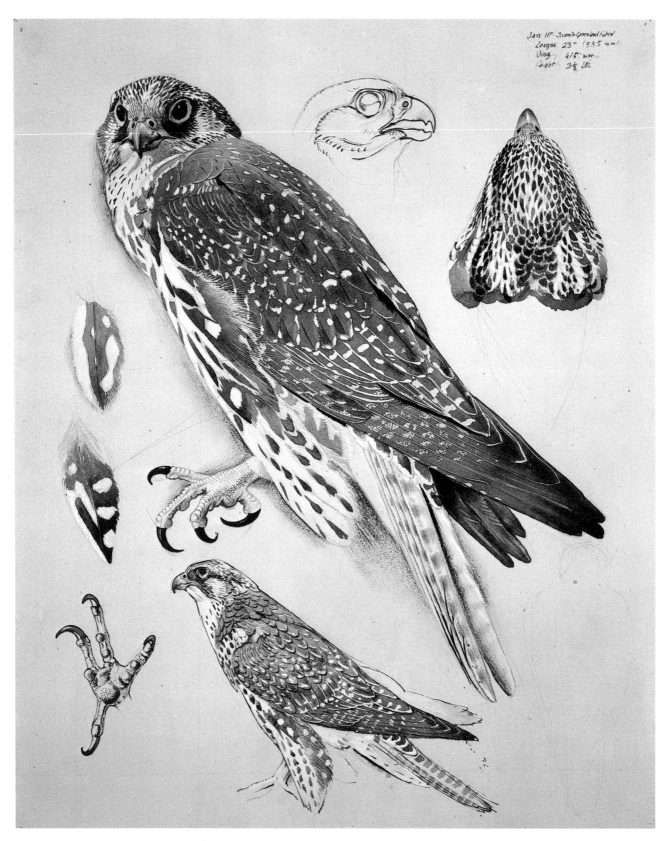

Measured drawings of a juvenile greenland falcon, January, undated.

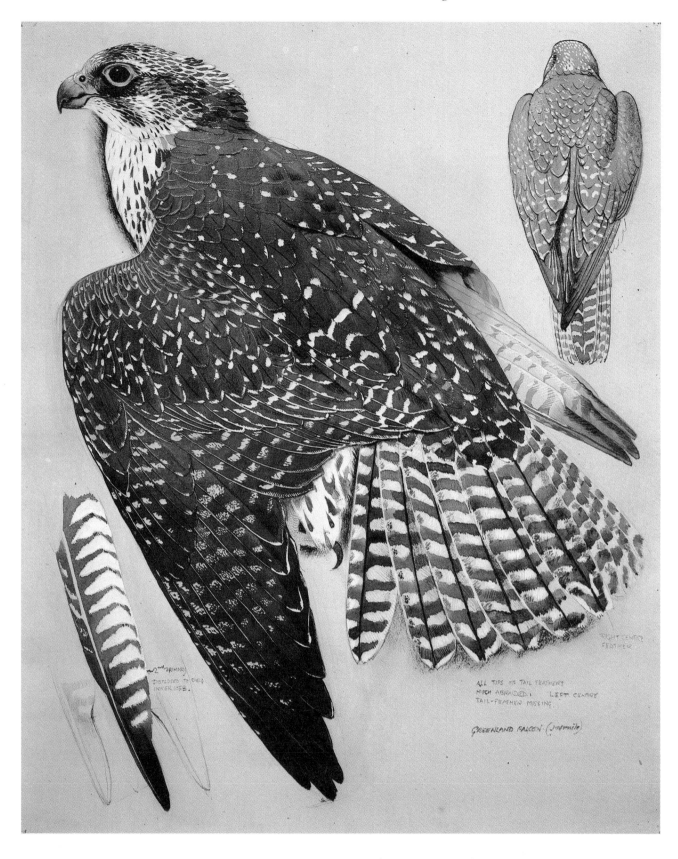

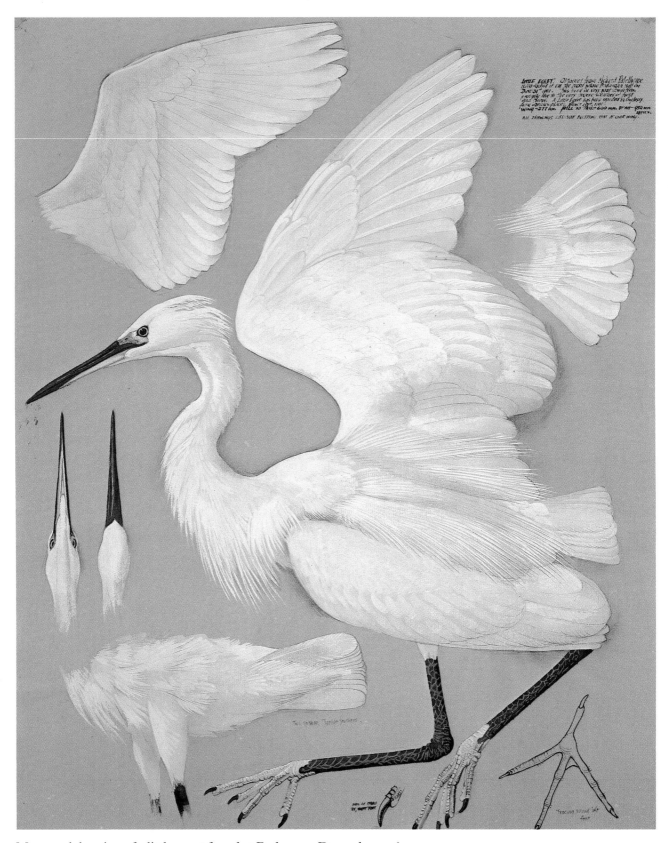

Measured drawing of a little egret found at Bodorgan, December 1961.

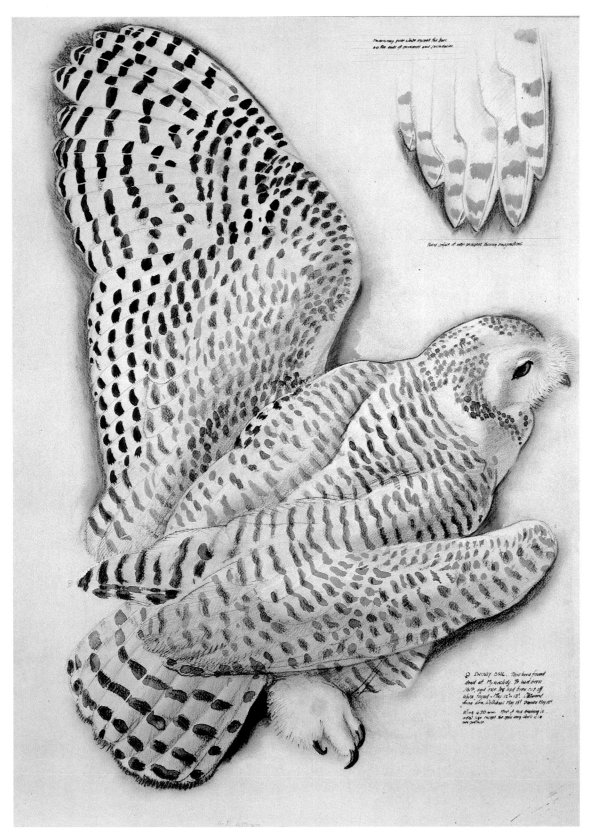

Measured drawing of a female snowy owl found shot at Mynachdy, May 1972.

~ 8 ~

Retrospect

FRIENDS OF TUNNICLIFFE who have a somewhat limited impression of his life and work are inclined to say that his black and white work was his best, and his best was done in the first flush of his youth and early manhood. Time will tell. Before he was thirty he certainly did many very fine etchings and engravings.

Was the 'flair', if that is the proper word for it, entirely youthful? Flair is a temporary flourish, a lighting up of the world about. Tunnicliffe was middle-aged before he was universally acclaimed for bird portraiture, and it is as a bird artist he will be judged, and marked down. Yet his early pictures of bulls and horses are among his finest work. He was fifty-three when he became a full member of the Academy, hardly in the first flush of youth. Although he had been admitted as a wood-engraver most of the work he submitted comprised bird portraits in watercolour. By the mid 1940s bird study had become Tunnicliffe's almost obsessional interest. He filled cupboards and bookcases with diary notes and sketches, making literally thousands of field sketches and post mortem measured drawings.

Black and white work, whether or not it is his finest achievement, occupied almost exclusively the early years of his career as an artist, first as an etcher and engraver on metal then, when etching ceased to be fashionable, as an engraver on wood and book illustrator. After 1938, due to eye-strain, he increasingly adopted scraperboard for book illustration, less demanding than wood-engraving and faster. He certainly became one of the most effective and skilful users of scraperboard of any contemporary illustrator. But in spite of its taxing problems he loved wood-engraving and right up to 1950 and beyond he was exhibiting superb examples at the Royal Academy and selling limited editions at absurdly low prices (the magnificent Long-Eared Owl illustrated here dates from 1955. The Little Owl, also illustrated, was done in 1956). Forty years after his correspondence with Norman Collins about wood-engravings for Mary Priestley's *Book of Birds*, Charles was invited by John Letts to illustrate a Folio Society edition of John Clare's bird poems. He was now seventy-six, but still hard at work, and his reply is typically down-to-earth, while affirming his life-long affection for the art of wood-engraving:

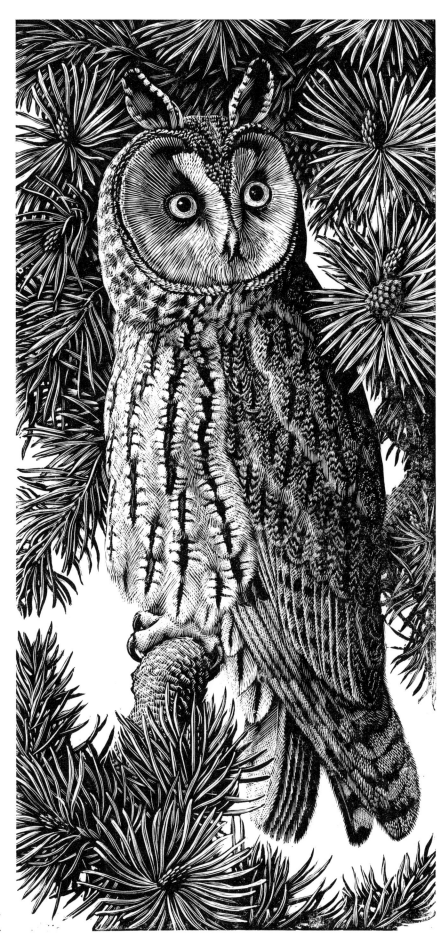

Long-eared owl.
Wood-engraving (1955).

Shorelands
December 7th 1977

Dear Mr. Letts,

Many thanks for your letter concerning the Folio Society Edition of John Clare's bird poems. This would seem to be an occasion for exquisite wood-engravings, and I would have welcomed the opportunity, years ago, to do these, but alas! wood-engraving has, for some time, been too much for my eyes, and I have not done any for some years. Scraper-board drawings have had to take the place of wood-engraving of late years, and even these are beginning to tax my eyes. I must therefore ask you to rule me out of the possibility of an edition of wood-engravings. In my present state I would be willing to do scraper-boards but these of course have not the austerity and severity of wood-engravings . . .

It was not only the eye-strain which prompted Tunnicliffe to seek new forms. The development of good colour printing by offset lithography opened new doors for the book illustrator and by the end of the 1930s wood-engraving was beginning to lose ground. The record in Charles's account book shows that several of his finest wood-engravings, produced in signed limited editions, did not sell readily, whereas his watercolour paintings were always snapped up on the first day of the Royal Academy Summer Exhibition. The collectors' market for etchings took a fatal knock in the Great Crash of 1929 and never recovered.

Going through his files one cannot help but be impressed by the craftsmanship of his early etching and engraving, and his faultless sense of balance and design. *The Bull* is one of his most celebrated etchings. Tunnicliffe has a feeling for the dramatic in depicting the behaviour, the movement of certain large animals such as bulls, and Shire horses at work. He was able to capture the movement, the sense of power in the very stance of the animal. *The Bull* stood in soft earth of the bank and hooked his short, thick horn into the roots of a tree. A person looking at this lifelike etching might feel an urgent need to get out of the way! His etching of duelling bulls, too, has the same power. One can feel the ground tremble, hear the massive creatures snorting and groaning as they strive to thrust one another back upon their haunches. Drama was at the killing of the family pig, the hauling and pushing of the beast to the slaughter block, someone putting all his strength into forcing the large animal along from the rear, another pulling on the rope, and the pig discouraged from complaining to the whole parish by a noose round its snout. The impression the killing of the pig made upon young Tunnicliffe is to be seen in these dramatic etchings. It was a fact of life that the pig was to die, its spouting blood caught in a bucket, while Tunnicliffe senior, the young artist and his sister, all played their part in preventing its escape and holding it while the pig-sticker did his work. Other etchings were more peacefully pastoral – haymakers, two men and a woman, accompanying two plodding horses, dappled greys, one man with a hayfork on his shoulder, the woman carrying the tea basket and the second man a flagon of beer, as they walked in the world of Millet and *The Sower*. There are lesser subjects, a very fine study of a hare, black and white pigs rooting round an old treestump, a turkey cock, a broody hen, *Colts in the Snow*, a black cow busy helping herself to a turnip while the farmer, Tunnicliffe, climbs the gate to get her out. "She was a bitch, that black cow," Charles Tunnicliffe the artist said, mixing his

An impression from memory. A flock of knot wheeling above the sands of Malltraeth Bay in the evening sunlight. "Wonderful colour after a stormy day."

Distant peaks of the Welsh mountains sketched at low tide from the beach at Malltraeth Bay. Tunnicliffe has noted the Welsh names of the mountains.

animals a little. "She could jump like a stag. That one should have been called *The Thief*." But he had already given this title to another etching of a bull with a chain around its neck and, hanging on the chain like the bar on a fob, a tree trunk to prevent the animal breaking into fields where there were crops. (This is one of Charles's best etchings and may be seen in the Victoria & Albert Museum.) There was another touch of drama in two etchings depicting the birth of a calf: in one, the cow is still down, anxiously watched over by the farmer's wife. The second of these two shows man and wife wheeling the newly-born calf to the farm in a barrow. Tunnicliffe didn't say whether or not the cow got to her feet. A cow that doesn't rise almost invariably dies. Then there was another etching of a gypsy family on their cart on Salisbury Plain, one of the bargee's wife leading the horse on the towpath of the canal, and *The Singing Ploughman*, a Millet figure leaning back as he rides home at the end of his day. Finally the same ploughman eating his 'bite' at the headland while his horse stretches out of the collar to snatch a mouthful of grass. All of these were sizeable plates. Some were aquatinted, among them the very first things Tunnicliffe offered for *Tarka*.

The earliest of his etchings include the classical subjects a young student was expected to tackle – Hercules and the Bear and Andromeda. It would have been strange if he had not done an etching of old Malcolm Salaman, portly and very comfortable in his seat, but as a subject a very far cry from any of those the young artist would choose when he left London and the Royal College of Art. Out in the country Tunnicliffe never had to look far, for it was all there, the hungry sheep in the snow, the spotted sow, the Herdwick ram, the mowing machine, three little pigs . . . all of these made subjects for his etchings.

As he developed his distinctive style in watercolour painting, it was bird portraiture which became his principal subject and about which he was soon afterwards to write his excellent and thoughtful book. In this work there was the special requirement of ornithological accuracy and detail, something which, in the ordinary way, a watercolourist might not be too concerned about. But, equally important for Tunnicliffe was the tremendous importance of composition and the artistic satisfaction to be gained from his chosen subjects. He really enjoyed the work when his subject was full of character, like a turkey cock, with its divinely contrived arrangement of feather markings. He loved to compose groups of birds, a skill at which he proved to be a master. He had learnt well from studying Chinese painting, its delicacy of colour and harmonious composition. One of his important standards was reality without anything sentimental.

In bird portraiture he diligently applied himself to drawing from life as he had drawn farm animals, until he knew his birds and could capture them as he had captured the bull, the working horse and those pigs lying snugly against one another, pink, well-fed, well-rounded and asleep. He could do this when an owl or a heron was his subject, a duck on the water, asleep with its bill buried in the feathers of its wing. The purpose was increasingly a double one, to satisfy a consuming interest in ornithology and to practise his art.

Few artists are able to sit on their work and wait for the world to come to see it. A good part of Tunnicliffe's work went straight into private hands, but there were the Academies and the galleries, and pictures to be sold when the public appreciated the work. And the public certainly appreciated it. The six pictures he would do for the Academy each year didn't hang

long without the red 'sold' sticker being attached. Tunnicliffe had had his work exhibited at Rowland Ward's Gallery and when The Hon. Aylmer Tryon opened his new gallery in Dover Street he was delighted to continue to exhibit Tunnicliffe's paintings there. Indeed the Tryon, and the Moorland Gallery associated with it, both played an important part in bringing Tunnicliffe's work to the attention of those who love bird paintings. His painting was brought before the mass audience of bird lovers and ornithologists through his work for the R.S.P.B. – the long series of covers for *Bird Notes*, and the many Christmas cards, made during a formative period in the Society's history, a distinctive visual impact, creating an image for the Society which did much to hold and increase its membership.

Last years

From 1959 onwards Tunnicliffe began to find it difficult to keep pace with commissions. People importuned him for all kinds of natural history subjects as well as pictures that would go well in certain rooms or on certain walls. A professional painter must supply what his public asks for – an exotic bird, a bearded monkey, a cockatoo, a gun dog, wild geese or the falconer's bird. Art is in the eye of the beholder, and, as a professional, Charles contrived to satisfy his own taste while meeting the requirements of the person who gave him the commission. It would all have rolled on comfortably enough had he not been concerned about Winifred's health, and there was cause for grave concern. They had been collaborating on a book which they planned to publish in their joint names. So much of their life had been collaboration of a less obvious sort and it was a satisfying thought that they would work together, but this project had soon to be abandoned. Winifred's illness required expert medical attention and even specialists seemed unable to help. When she died in 1969 Shorelands became a desolate place and there was nothing to brighten or enliven the day. Tunnicliffe's own health suffered and he had a heart attack following surgery. When he returned to Anglesey he spent his entire time on commissioned work and his post mortem drawings, turning back offers of book illustration and commercial work. A few years passed and his commissions increased so steadily that he was hard put to it to do his six pictures for the Academy and fit everything in, but at least he was able to occupy his mind and get over the loss of Winifred by working. People who knocked on his door wanted to dally and talk about birds or ask his opinion of their own work, overlooking the fact that his life was discipline. He needed to achieve so much at the drawing-board or easel every day when the light was good enough. He travelled very little, but one day, taking his sister with him, he made a journey by car and crashed. Neither he nor Dorothy suffered serious injury, but both were shocked. Tunnicliffe's doctor subsequently discovered that he was diabetic. The accident affected the general condition of his health. His balance was affected. Worse than any of these, his eyesight deteriorated.

When Tunnicliffe and I began our series of sittings for my 'portrait of the artist', as we agreed to call it, (he assured me there was nothing remarkable in what he had achieved!) we

Swans gliding down to Malltraeth Lake, c.1950. From a sketchbook at Shorelands.

talked about the serious setback to his plans for the following year's Summer Exhibition at the Academy. He worked a year in advance and spent quite a time making up his mind about what he would send. His eyes were getting no better and he blamed the years he had spent wood-engraving – "all that work for that bloody man Williamson. All those hours I spent on acutely difficult work on the end-grain!" He discounted the possibility that his eyes were getting worse by reason of his complaint because his diabetic condition was not serious. He agreed, after much persuasion on my part, to go and have a check-up. There was a possibility that an eye specialist might be able to solve the seemingly mechanical problem of working close, to do fine work with brush or pen, and standing back to complete the work without having to change glasses or lose the definition of what had been previously done. Tunnicliffe's technique was an exacting one. The fineness was equal to that called for in the use of the graver. Only by working in this way could he make his post mortem drawings. Nearly all of his bird portraits were of the same kind and called for accurate work, but he found it hard to explain to a man who was not a painter. It was not as simple as supplying him with bi-focals to watch television and read a book. The fact was that his eyes tired, the sharp focus was quickly lost and he had to stop painting almost as soon as he had touched the paper with the brush. His check-up involved ten days in hospital, but whatever else his medication

achieved, it didn't prevent the further deterioration of his eyesight. Tunnicliffe was mortified to find that when he painted something it was distorted. For a while we talked about it every time we met. He was depressed when, one day, without thinking, I asked him if a pair of horses he had set out to paint hauling a plough round on the headland of the field were Clydesdales. They were Shires, although they had the lighter, slightly rangy look of the Clydesdale. They seemed to be leaning over. The picture had an impressionistic style that wasn't Tunnicliffe's. It had been intended as the first of the six pictures he would paint for the Academy in 1979. His subsequent attempts were no more satisfactory, but he avoided talking about them, and I was careful to say nothing more about painting. We talked about the way he had come from Sutton Lane Ends Farm, and a boyhood drawing horses and pigs, to being a senior member of the Royal Academy and that summer, an O.B.E. His book, *Shorelands Summer Diary*, had been well titled, for it had been about the very summertime of his life on Anglesey. Now it was coming on towards autumn and it was sad. I remember one day drawing his attention to a hawk that seemed to be battling its way, head-down against a buffeting wind blowing down the estuary, the sort of thing he would have captured for his sketchbook, for he was a draughtsman who could get a thing on paper in a matter of minutes. "I could draw that bird from memory," he told me, "if only my damned eyes would let me." He had, of course, drawn it hundreds of times, flying like that, swooping down to perch, flipping back into the air and driving its slim body with those rounded, short wings after a flock of terrified finches. What could I say to him? A painter who cannot see to paint is as tragically afflicted as a composer who cannot hear his music played.

"I have retired," he told me one day. "I have given up." It was even harder to know what to say. His sister Dorothy told me how frustrated he was, and how sorry she was for him, for she knew how much his work occupied his life. There was nothing else he cared to do. His hand was steady enough, but painting was no longer possible. We were preparing some of his work for publication, selecting some of his engravings and etchings from his stock of prints put away and now brought out to be examined. Tunnicliffe looked at his early work with renewed interest and began to instruct Dorothy in pulling prints from the wooden blocks. He even thought he might try his hand at the graving tools and recapture his youth, but of course his eyesight would no more let him do an engraving than it would let him paint. He was frustrated but he persisted. One day he dropped me a line to enquire if I had taken away three books he couldn't lay hands on. Normally he would have telephoned but this time he hesitated to ring me up and wrote, instead, the last letter he would write to anyone. I telephoned. "It's that bloody man Williamson again!" he said. "Where do you think he is?" We both laughed when I told him where I was sure Williamson was. Tunnicliffe was in great form, seeming to have got over the depression he had felt over not being able to carry on. I told him where I knew he could put his hand on the three books – *The Peregrine's Saga, The Lone Swallows* and *The Old Stag*. If he didn't find them where I said they were, on the shelf in his studio, I would come and stay with him until I found them for him. We laughed again and that was that. On the following day he made some more prints with Dorothy's help and used wood-engraving tools for some television people who arrived to do some filming. That evening, overtaxed as he undoubtedly was, he lay back and slept in his chair before the fire.

His final heart attack was quickly over. His sister told me the following morning that he had not suffered.

I couldn't help thinking how our paths had crossed and how well I had come to know him in the last fateful years of his life. I think that what I found so fascinating about him was his instinctive knowledge of the ways of living creatures. He could see what I could see without myself being able to put it on paper or canvas. His was an uncanny ability to record the essential life in things, and most people recognised this in his work. In my particular case it perhaps went a little further for I knew the smells and the sounds that his simplest sketches brought to mind, the slipperiness of the midden plank, the twittering of young swallows being fed, the scent of the hayfield on a warm afternoon, the consistency of farmyard mud. When I talked to him about what was in his sketches he would smile and we would both enlarge upon the things suggested. Here so far as I was concerned, was a kindred spirit as well as a great artist. I had become very fond of him. He had almost waywardly set out to be what he wanted to be, and worked compulsively all his life until his powers failed.

Epilogue

In 1975 Charles Tunnicliffe was awarded the Gold Medal of the R.S.P.B. Another fine artist, Eric Ennion, wrote this tribute:

> For half a century we who know and love the countryside have enjoyed Charles Tunnicliffe's art in books and periodicals and exhibitions: a colourful, apt and factual commentary upon wildlife in all its forms as the seasons passed and the mass of his drawings grew – birds, beasts, berries, flowers, unfolding leaves, lichened stones and frosted grass, every detail clear and true. But for most of us it was his personal member's exhibition at the Royal Academy in 1974 that made us realise the measure of this man. The sheer breadth of knowledge, care and infallible expertise of a lifetime's work was revealed – and this was only part of it. May we please see more.

It was in response to this that Gollancz published a collection of Charles's colour sketches in July 1979. As a final word on his achievement, one could not do better than quote the words of two fellow artists, John Busby and Noel Cusa:

> I recall vividly my excitement as a boy and budding artist, with illustrations for Henry Williamson's books and later with those of Grant Watson's *Walking with Fancy*, H. E. Bates' *O More than Happy Countryman*, Richard Church's *Green Tide* and Tunnicliffe's own *Mereside Chronicle*. I loved the buoyant feeling of flight – the peregrine's eye view, and particularly the poetic aspiration in these works which though superbly decorative achieved so much more. I admire all his work that captures a sense of encounter with wild creatures and conveys the uniqueness and unpredictability of such moments.
>
> *(John Busby)*

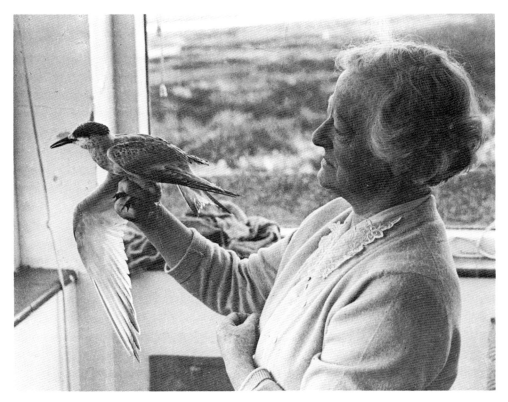

Winifred with an injured tern at Shorelands in 1967.

Charles Tunnicliffe at work, Shorelands, April 1974.

May 1972. At work on a measured drawing of a snowy owl (illustrated on page 145).

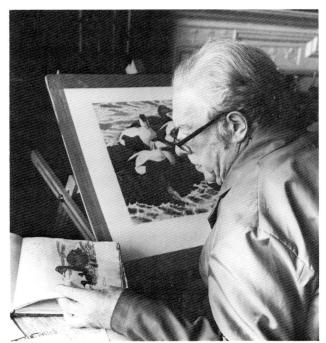

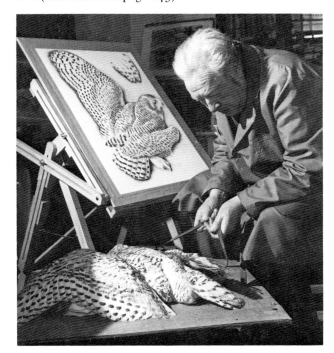

Photographs on this page by Seán Hagerty.

[155]

To my eye there is no painting more superbly exciting than the six watercolours of his annual exhibit at the Royal Academy, and those, years ago, that he used to exhibit at the Manchester Academy. I remember favourites: the splendid paintings of the South Stack peregrines, fierce and sun-drenched; puffins and lichen on Skomer; terns and sandpools; and a recent masterpiece *Hooligans*, a gambolling trio of lambs putting to scattered flight a flock of golden plover. He is a flawless draughtsman. His birds and animals are solid, round and shapely; beautifully observed and unmistakable, however slight the sketch, and correct in perspective and scale. He is, moreover, not content simply to regard a bird as a zoological specimen, but treats it as a living creature of characteristic posture and behaviour, splendid with life and vigour in its setting of light and landscape. Tunnicliffe is also clearly fascinated by movement and peculiarly successful in his treatment of it; birds running, taking off, alighting; birds standing head down to a wind, the breeze-lifted feathers so naturally indicated that the gust can be felt. Not for him the sad disorder of a taxidermist's error! Movement too, of the setting: wind-blown jetsam on a beach with ringed plovers, the birds barely maintaining their stance; tossed leaves, heeling grasses. All are represented with consummate skill and imagination. But perhaps above all, he has an unmatchable flair for portraying water and the movement of water, for few have painted the ripples and waves and spray and reflections, refractions, shimmer and sparkle of water as Tunnicliffe has done.

When, shortly before he died, I discovered that Charles had been awarded the O.B.E. in 1978, I taxed him with his excessive modesty. His reply, which I noted, perfectly sums up his approach to life and to art: "I am not a man for parading in medals," he said with a shrug. "It gives me great satisfaction to have my work recognised, to have it appreciated. I wouldn't be human if it didn't. Just the same, I must say that I find something incongruous in being honoured for doing what I love doing, or for earning my living, as I have done, by cultivating what talent I have."

⟾ BIBLIOGRAPHY ⟾

1. Books written and illustrated by C. F. Tunnicliffe

My Country Book. The Studio, 1942. Title-page vignette, 16 colour plates and 80 monochrome illustrations. 2-colour scraperboard dust-jacket.

Bird Portraiture. The Studio, 1945. Title and dedication-page vignettes, 16 colour plates and 85 monochrome illustrations. Dust-jacket in colour.

How to Draw Farm Animals. The Studio, 1947. Title and dedication-page vignettes, 26 full-page and 27 monochrome illustrations in pencil, chalk and scraperboard. 1 repeated on dust-jacket.

Mereside Chronicle. Country Life, 1948. Frontispiece, title-page vignette, 1 full-page and 207 illustrations and 6 pages of pictorial maps of meres; all monochrome wash-drawings. Monochrome wash-drawing on dust-jacket.

Birds of the Estuary. Penguin Books, 1952. (Puffin Picture Book, No. 90). 16 pages in colour, including both paper covers, and 16 pages in monochrome.

Shorelands Summer Diary. Collins, 1952. Frontispiece, title-page vignette and 185 vignetted scraperboards. 16 full-page colour plates. Dust-jacket in 3 colours.

Wild Birds in Britain. Happy House, 1974. Text and illustrations from the Album of Brooke Bond tea cards of the same name, published in 1965. 50 colour illustrations. 1 full-page and 23 vignetted scraperboards. Covers in colour, using part of front cover of original Album.

A Sketchbook of Birds. Victor Gollancz, 1979. Introduction by Ian Niall. 123 pages of colour drawings from the artist's seventeen sketchbooks. Title-page vignette in colour, a detail from page of sketches. Dust-jacket in colour.

2. Books and Booklets illustrated in whole, or in part by C. F. Tunnicliffe

Tarka the Otter by Henry Williamson. G. P. Putnam's Sons, 1932. Frontispiece and 23 full-page wood-engravings, 16 line-drawn vignettes.

The Lone Swallows by Henry Williamson. G. P. Putnam's Sons, 1933. Frontispiece and 23 full-page wood-engravings, 34 line-drawn vignettes.

The Old Stag by Henry Williamson. G. P. Putnam's Sons, February 1933. Frontispiece and 23 full-page wood-engravings, 9 line-drawn vignettes.

The Star Born by Henry Williamson. Faber and Faber, May 1933. Title-page vignette, 15 full-page and 19 vignetted wood-engravings. Wood-engraving on dust-jacket not included in book.

The Dull House by Kit Higson. Putnam, 1934. Frontispiece in 3 colours, 8 full-page black-and-white illustrations.

Beasts Royal by Richard Patrick Russ. Putnam, September 1934. Frontispiece in colour, 8 full-page monochrome wash drawings.

Tales from Ebony by Harcourt Williams. Putnam, September 1934. Frontispiece in colour, 31 full-page colour plates, 59 line-drawn vignettes.

New edition published by Nattali and Maurice, 1947, contained illustrations as above, but with a new frontispiece.

The Peregrine's Saga by Henry Williamson. Putnam, 1934. Frontispiece and 12 full-page wood-engravings, 12 line-drawn vignettes.

Salar the Salmon by Henry Williamson. Faber and Faber, 1935. Title-page and end-piece, vignetted wood-engravings. Line-drawn maps on coloured endpapers. Full dust-jacket in colour.

First illustrated edition, October 1936. Title and dedication-pages, vignetted scraperboards. 16 full-page colour plates and 48 vignetted scraperboards. 23 scraperboard vignettes on endpapers.

New edition, 1948, contains the same title and dedication-page vignettes; 47 scraperboard vignettes, 2 of which are new.

Pool and Rapid by R. L. Haig-Brown. Jonathan Cape, 1936. Frontispiece, title and half-title-page vignettes and 1 full-page scraperboards. Two-colour line and brush decorated endpapers. Two-colour scraperboard dust-jacket.

A Book of Birds by Mary Priestley. Victor Gollancz, 1937. 9 full-page and 72 vignetted wood-engravings, one repeated on title-page.

The Sky's Their Highway by Kenneth Williamson. Putnam, October 1937. 8 full-page wood-engravings, one repeated on dust-jacket.

The Seasons and the Farmer by F. Fraser Darling. Cambridge University Press, 1939. 47 scraperboard vignettes, 3 repeated on book cover, title-page and last page.

The Seasons and the Gardener by H. E. Bates. Cambridge University Press, 1940. 51 scraperboard vignettes, 1 repeated on title-page. 1 full scraperboard on book cover, repeated on dust-jacket with second colour.

The Seasons and the Woodman by D. H. Chapman. Cambridge University Press, 1941. 52 scraperboard vignettes, 1 repeated on title-page and book cover.

The Seasons and the Fisherman by F. Fraser Darling. Cambridge University Press, 1941. 50 scraperboard vignettes, 1 repeated on title-page. Full decorative scraperboard on book cover and dust-jacket.

Nature Abounding. Edited by E. L. Grant Watson. Faber and Faber, 1941. Title-page and 4 other vignetted scraperboards. 1 repeated on dust-jacket.

New edition, 1951. Vignettes as first edition, 6 full-page and 31 additional vignetted scraperboards. 3 repeated on dust-jacket.

In the Heart of the Country by H. E. Bates. Country Life, 1942. Title-page vignette, 14 full-page and 14 vignetted scraperboards. 1 repeated on dust-jacket.

Going Fishing by Negley Farson. Country Life, 1942. Frontispiece, 15 full-page and 10 vignetted scraperboards.

O More than Happy Countryman by H. E. Bates. Country Life, 1943. Frontispiece, 10 full-page and 15 vignetted scraperboards.

My Friend Flicka by Mary O'Hara. Eyre and Spottiswoode, 1943. Title-page vignette and 35 vignetted scraperboards.

Country Hoard by Alison Uttley. Faber and Faber, 1943. 25 vignetted scraperboards, 1 repeated on title-page. 2 repeated on dust-jacket.

Walking with Fancy by E. L. Grant Watson. Country Life, 1943. Frontispiece, title-page vignette, 5 full-page and 50 vignetted scraperboards.

Exploring England by Charles S. Bayne. William Collins, 1944. 13 full-page and 23 vignetted scraperboards. Full 2-colour scraperboard dust-jacket.

Farmer Jim by D. H. Chapman. George G. Harrap, 1944. Frontispiece, 3 full-page and 10 vignetted scraperboards. Dust-jacket.

The Care of Farm Animals by F. Fraser Darling. Oxford University Press and National Federation of Young Farmers' Clubs, 1944. Title-page vignette, 3 full-page and 24 vignetted line-drawings.

The Call of the Birds by Charles S. Bayne. Collins, 1944. 10 full-page and 18 vignetted scraperboards. Full 2-colour scraperboard dust-jacket.

Communications Old and New by Lt. Cdr. R. T. Gould, R.N. The R.A. Publishing Co. Ltd., for Cable and Wireless Ltd. No date. Cover and title-page vignettes and 28 scraperboards.

Green Tide by Richard Church. Country Life, 1945. Frontispiece, title-page vignette, 13 full-page and 29 vignetted scraperboards. 1 repeated on dust-jacket.

The Country Child by Alison Uttley. Faber and Faber, 1945. 8 full-page and 38 vignetted scraperboards. 1 repeated on title-page. 1 repeated on dust-jacket.

The Wonders of Nature by R. I. Pocock and others. Odhams Press, no date. (Reprinted 1946.) Title-page scraperboard vignette, 55 half- and full-page composite line and chalk drawings. Map on endpapers.

Wandering with Nomad by Norman Ellison. University of London Press, 1946. Title-page vignette, 6 full-page and 36 vignetted scraperboards. 2-colour scraperboard dust-jacket.

Country Things by Alison Uttley. Faber and Faber, 1946. Title-page vignette, 32 vignetted scraperboards. 4 repeated on dust-jacket.

Happy Countryman by C. Henry Warren. Eyre and Spottiswoode, 1946. Title-page vignette, 17 vignetted scraperboards. 2-colour scraperboard dust-jacket.

The Art of Scraperboard by Robert Forman. Clifford Milburn, 1946. Includes 3 vignetted scraperboards, originally drawn for advertisements.

Out of Doors with Nomad by Norman Ellison. University of London Press, 1947. Frontispiece, title-page vignette, 5 full-page and 43 vignetted scraperboards. 2 colour scraperboard dust-jacket.

Fishing and Flying by Terence Horsley. Eyre and Spottiswoode, 1947. Title-page vignette and 40 vignetted scraperboards. 2-colour scraperboard dust-jacket.

The Long Flight by Terence Horsley. Country Life, 1947. Frontispiece and 18 full-page scraperboards in black on buff coloured panels. 2-colour scraperboard dust-jacket.

Letters from Skokholm by Ronald M. Lockley. J. M. Dent, 1947. Frontispiece and 50 vignetted scraperboards, 1 repeated on title-page. Map, with 5 of the text drawings, printed in blue on endpapers. 2 other drawings repeated on dust-jacket.

Farmer's Creed by Crichton Porteous. George G. Harrap, 1947. Frontispiece and 18 vignetted scraperboards, 3 repeated.

Angling Conclusions by W. F. R. Reynolds. Faber and Faber, 1947. 27 vignetted scraperboards, 1 repeated on title-page and 3 repeated on dust-jacket. 19 diagrams prepared and hand lettered on scraperboard.

Our Bird Book by Sidney Rogerson and Charles Tunnicliffe. Collins, 1947. Frontispiece in colour, 31 full-page colour plates (containing 51 illustrations) and 84 vignetted scraperboards. 1 colour illustration on dust-jacket.

The Leaves Return by E. L. Grant Watson. Country Life, 1947. Frontispiece, title-page vignette, 5 full-page and 41 vignetted scraperboards. 1 repeated on dust-jacket.

The Children's Wonder Book in Colour. Odhams Press, no date but around 1948. Includes 5 full-page plates in colour and 2 vignetted scraperboards illustrating *Well-known Birds in Britain* by Oliver Pike.
Also *Some British Trees and how we use them*, 2 full-page colour plates.

Over the Hills with Nomad by Norman Ellison. University of London Press, 1948. Frontispiece, title-page vignette, 5 full-page and 45 vignetted scraperboards. 2-colour scraperboard dust-jacket.

The Cinnamon Bird by Ronald M. Lockley. Staples Press, 1948. Title-page scraperboard vignette, 4 full-page colour plates. Dust-jacket in colour.

Carts and Candlesticks by Alison Uttley. Faber and Faber, 1948. 26 vignetted scraperboards, 1 repeated on title-page. 2 repeated on dust-jacket.

Come Sketching with Sir Frank Brangwyn and others, by Percy V. Bradshaw. Studio, 1949. Includes C. F. Tunnicliffe, and illustrates the chapter with 10 extracts from sketchbooks.

Roving with Nomad by Norman Ellison. University of London Press, 1949. Frontispiece, title-page vignette, 3 full-page and 34 vignetted scraperboards. 2-colour scraperboard dust-jacket.

Wild Life in a Southern County by Richard Jefferies. Lutterworth Press, 1949. Frontispiece, 7 full-page and 13 vignetted wood-engravings.

Both Sides of the Road by Sidney Rogerson and Charles Tunnicliffe. Collins, 1949. Frontispiece in colour, 22 full-page colour plates and 107 vignetted scraperboards. Colour illustration on dust-jacket not included in book.

The Saturday Book, 9. Edited by Leonard Russell. Hutchinson, October 1949.
Includes *Flowers in Buckinghamshire* by Alison Uttley. 4 vignetted scraperboards.

The Farm on the Hill by Alison Uttley. Faber and Faber, 1949. 8 full-page and 41 vignetted scraperboards, 1 repeated on title-page. 1 repeated on dust-jacket.

Rivermouth by Brian Vesey-Fitzgerald. Eyre and Spottiswoode, 1949. 6 full-page and 6 vignetted scraperboards, part of 1 repeated on title-page and whole drawing repeated on dust-jacket.

Profitable Wonders by E. L. Grant Watson. Country Life, 1949. Frontispiece, title-page vignette, 4 full-page and 44 vignetted scraperboards. 2-colour scraperboard dust-jacket.

Nature Through the Seasons in Colour. Odhams Press, no date. 6 colour plates.

Avocets in England by P. E. Brown, R.S.P.B. Occasional Publications No. 14, 1950. 4 full-page monochrome wash drawings.

Adventuring with Nomad by Norman Ellison. University of London Press, 1950. Frontispiece, title-page vignette, 2 full-page and 22 vignetted scraperboards. 2-colour scraperboard dust-jacket.

The Saturday Book, 10. Edited by Leonard Russell. Hutchinson, October 1950. Includes *Country Food: A Memory* by Alison Uttley. 4 vignetted scraperboards.

Come Out of Doors by C. D. Dimsdale. Hutchinson, 1951. Frontispiece in colour, 4 full-page colour plates, 30 vignetted scraperboards. Dust-jacket in colour.

Northwards with Nomad by Norman Ellison. University of London Press, 1951. Frontispiece, title-page vignette, 2 full-page and 20 vignetted scraperboards. 2-colour scraperboard dust-jacket.

The Saturday Book, 11. Edited by Leonard Russell. Hutchinson, October 1951. Includes *The Personality of Trees* by Alison Uttley. 4 vignetted scraperboards printed in terra cotta.

Ambush of Young Days by Alison Uttley. Faber and Faber, 1951. 8 full-page and 45 vignetted scraperboards, 1 repeated on title-page. 2 repeated on dust-jacket.

Under the Sea-wind by Rachel L. Carson. Staples Press, 1952. 2 full-page scraperboards.

Oxford Junior Encyclopaedia. Oxford University Press, 1952. Includes 2 full-page colour plates, illustrating breeds of cattle and poultry.

Soho Centenary. Hutchinson, 1952. A gift from artists, writers and musicians to the Soho Hospital for Women. Includes 1 half-tone reproduction of a scraperboard, drawn originally for an I.C.I. advertisement.

Plowmen's Clocks by Alison Uttley. Faber and Faber, 1952. 7 full-page and 42 vignetted scraperboards.

Punchbowl Midnight by Monica Edwards. Collins, 1951. 15 vignetted scraperboards. Line-drawn map on endpapers. Dust-jacket in colour.

The Old Man and the Sea by Ernest Hemingway. The Reprint Society by arrangement with Jonathan Cape, 1953. 4 full-page (1 repeated as frontispiece) and 16 vignetted scraperboards (1 repeated on title-page). Also 18 drawings by Raymond Sheppard.

Rural Studies Book 4 by J. C. W. Houghton. J. M. Dent, 1953. 20 vignetted scraperboards.

Puffins by Ronald M. Lockley. J. M. Dent, 1953. Frontispiece in colour, repeated on dust-jacket. Line-drawn illustrations by Nancy Catford.

Here's a New Day by Alison Uttley. Faber and Faber, 1956. 30 vignetted scraperboards, 1 repeated on title-page. 2 repeated on dust-jacket.

A Year in the Country by Alison Uttley. Faber and Faber, 1957. Title-page vignette (repeated on dust-jacket) and 13 vignetted scraperboards.

The Farm by M. E. Gagg. Wills and Hepworth, 1958. (A "Ladybird" Book, Series 563). Book cover and title-page vignetted scraperboards, 24 full-page colour plates, 1 repeated on dust-jacket.

Pirates and Predators by R. Meinertzhagen. Oliver and Boyd, 1959. Includes 2 full-page screened scraperboards.

The Swans Fly Over by Alison Uttley. Faber and Faber, 1959. Title-page vignette (repeated on dust-jacket) and 14 vignetted scraperboards.

What to Look for in Winter by E. L. Grant Watson. Wills and Hepworth, 1959. (A "Ladybird" Book, Series 536). Book cover and title-page vignetted scraperboards, 24 full-page colour plates, 1 repeated on dust-jacket.

Something for Nothing by Alison Uttley. Faber and Faber, 1960. Title-page vignette and 16 vignetted scraperboards. 3 repeated on dust-jacket.

What to Look for in Summer by E. L. Grant Watson. Wills and Hepworth, 1960. (A "Ladybird" Book, Series 536). Book cover and title-page vignetted scraperboards. 24 full-page colour plates, 1 repeated on dust-jacket.

What to Look For in Autumn by E. L. Grant Watson. Wills and Hepworth, 1960. (A "Ladybird" Book, Series 536). Book cover and title-page vignetted scraperboards. 24 full-page colour plates, 1 repeated on dust-jacket.

British Birds of the Wild Places by J. Wentworth Day. Blandford Press, 1961. 12 colour plates (containing 49 illustrations), title-page and 18 vignetted scraperboards, 1 repeated on book cover. 3 colour illustrations repeated on dust-jacket.

All colour illustrations, and 10 scraperboards, reprinted from *Bird Portraits*, a set of 50 Brooke Bond tea cards and the accompanying album.

Drawing for 'Radio Times'. Foreword by R. D. Usherwood. The Bodley Head, 1961. Includes 4 vignetted scraperboards drawn for *Radio Times*.

What to Look For in Spring by E. L. Grant Watson. Wills and Hepworth, 1961. (A "Ladybird" Book, Series 536). Book cover and title-page vignetted scraperboards. 24 full-page colour plates, 1 repeated on dust-jacket.

Wild Flowers of the Countryside by A. J. Huxley. Blandford Press, 1962. 11 colour plates (containing 50 illustrations) and 18 vignetted scraperboards, 1 repeated on title-page and 1 on book cover and dust-jacket. 3 colour illustrations repeated on dust-jacket.

All illustrations reprinted from *Wild Flowers*, Series 2, a set of 50 Brooke Bond tea cards and the accompanying album.

Wild Honey by Alison Uttley. Faber and Faber, 1962. Title-page vignette and 16 vignetted scraperboards. 2 repeated on dust-jacket.

Birds and Woods by W. B. Yapp. Oxford University Press, 1962. Frontispiece scraperboard, repeated on dust-jacket.

A New Dictionary of Birds. Edited by A. Landsborough Thomson. Nelson, 1964. Includes 1 colour plate, illustrating "Characteristic Northern Birds."

Cuckoo in June by Alison Uttley. Faber and Faber, 1964. Title-page vignette and 16 vignetted scraperboards. 1 repeated on dust-jacket.

The Way of a Countryman by Ian Niall. Country Life, 1965. Title-page vignette, 3 full-page and 14 vignetted scraperboards (1 repeated as 13 chapter headings). Dust-jacket scraperboard.

Dawn, Dusk and Deer by Arthur Cadman. Country Life, 1966. Title-page vignette, 5 full-page and 27 vignetted scraperboards (1 repeated 9 times). Detail of full-page illustration repeated on dust-jacket.

The Shell Bird Book by James Fisher. Ebury Press, 1966. 2 full-page colour plates, originally commissioned by Shell for advertisements.

New Forest. Edited by Herbert L. Edlin. H.M.S.O., 1966. (Forestry Commission Guide). Front cover and 13 vignetted scraperboards.

Second impression, 1969, has front cover colour reproduction of watercolour painting.

The Taming of Genghis by Ronald Stevens. Faber and Faber, 1966. Title-page vignetted scraperboard, repeated on book cover and dust-jacket spine. Colour reproduction of watercolour painting on dust-jacket front.

A Peck of Gold by Alison Uttley. Faber and Faber, 1966. Title-page vignette and 18 vignetted scraperboards. 1 repeated on dust-jacket.

The Horse in the Furrow by George Ewart Evans. Faber and Faber, 1967. 29 vignetted scraperboards, 1 repeated on title-page and 9 other repeats. 3 repeated on dust-jacket.

A Galloway Childhood by Ian Niall. Heinemann, 1967. 5 full-page and 25 vignetted scraperboards. 1 repeated on dust-jacket.

A Fowler's World by Ian Niall. Heinemann, 1968. Title-page vignette, 5 full-page and 27 vignetted scraperboards. 1 repeated on dust-jacket.

The Button Box and Other Essays by Alison Uttley. Faber and Faber, 1968. Title-page vignette and 15 vignetted scraperboards. 2 repeated on dust-jacket.

The Valley by Elizabeth Clarke. Faber and Faber, 1969. Title-page vignetted scraperboard. 2 colour scraperboards on spine and front of dust-jacket.

The Island by Ronald M. Lockley. André Deutsch, 1969. 10 vignetted scraperboards and line-drawn map on endpapers. Dust-jacket in colour.

The Naturalist in Wales by Ronald M. Lockley. David and Charles, 1970. Includes 2 vignetted scraperboards.

A Ten o'Clock Scholar by Alison Uttley. Faber and Faber, 1970. Title-page vignette and 12 vignetted scraperboards. 1 repeated on dust-jacket.

The Complete Book of Game Conservation. Edited by C. L. Coles. Barrie and Jenkins, 1971. Includes 1 full-page colour reproduction of watercolour painting.

Gwydyr Forest in Snowdonia by Donald L. Shaw. H.M.S.O., 1971. (Forestry Commission Booklet No. 28). Frontispiece, 8 full-page and 7 vignetted scraperboards.

Secret Places by Alison Uttley. Faber and Faber, 1972. Title-page vignette and 12 vignetted scraperboards. 1 repeated on dust-jacket.

Orielton by Ronald M. Lockley. André Deutsch, 1977. 14 vignetted scraperboards.

To Speed the Plough by Ian Niall. Heinemann, 1977. 16 full-page scraperboards.

R.S.P.B. Book of British Birds by Linda Bennett. Hamlyn, 1978. 36 full-page colour plates from paintings originally commissioned by R.S.P.B. Line-drawn illustrations by Robert Gillmor.

Up with the Country Lark by Nellie W. Brocklehurst. Arthur H. Stockwell, 1978. Title-page vignette, 1 full-page and 5 vignetted scraperboards.

Compiled by Keith Cheyney and Robert Gillmor.